THE ART AND CRAFT OF
KEEPSAKE
PHOTOGRAPHY

Engagements & Weddings

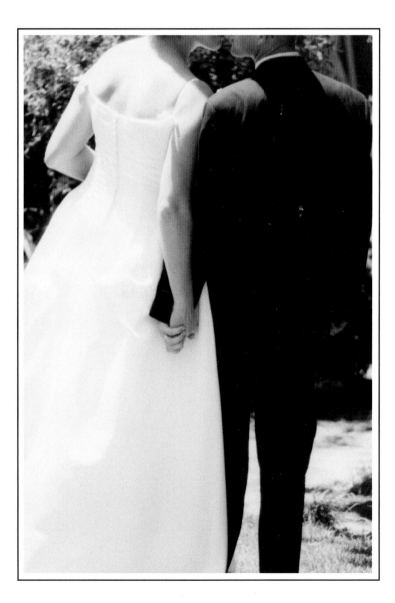

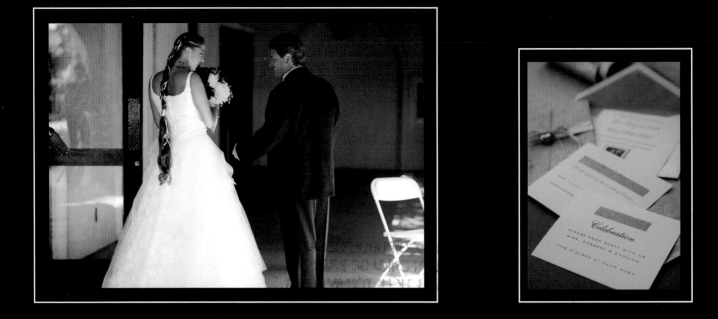

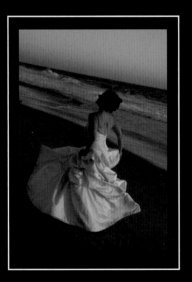

THE ART AND CRAFT OF
KEEPSAKE
PHOTOGRAPHY

Engagements & Weddings

*How to Take Perfect Photos and Make Stunning Invitations,
Announcements, Albums, Thank You Notes, and More*

Barbara Smith

Foreword by Skip Cohen

AMPHOTO BOOKS

An imprint of
Watson-Guptill Publications/New York

To my brother Larry . . . forever in my heart.

First published in 2007 by Watson-Guptill Publications,
a division of VNU Business Media, Inc.
770 Broadway, New York, NY 10003
www.watsonguptill.com

Library of Congress Cataloging-in-Publication Data

Smith, Barbara, 1947-
 The art and craft of keepsake photography engagements
and weddings : how to take perfect photos and make stun-
ning invitations, announcements, albums, thank-you notes,
and more / Barbara Smith.
 p. cm.
 Includes bibliographical references and index.
 ISBN-13: 978-0-8174-4115-9 (alk. paper)
 ISBN-10: 0-8174-4115-8 (alk. paper)
 1. Handicraft. 2. Photographs—Trimming, mounting, etc.
3. Souvenirs (Keepsakes) I. Title.
 TT857.S55 2006
 745.594'1—dc22
 2006013056

Editorial Director: Victoria Craven
Editor: Michelle Bredeson
Art Director: Julie Duquet
Designer: Pooja Bakri
Senior Production Manager: Alyn Evans

Manufactured in Singapore

First printing, 2007

1 2 3 4 5 6 7 8 9 / 15 14 13 12 11 10 09 08 07

SOC
Acknowledgments

I am a wealthy woman in that I have been blessed with an extraordinary family of both kin and kindred spirits who have consistently supported my vision and encouraged me on my path. Thank you all, thank you, thank you!

A special note of appreciation to Skip Cohen (*Rangefinder Magazine*/WPPI), Dan Steinhardt (Epson), Stacie Errera (Tamron), Castine Rees (Tamrac), Jim Christenson (Hahnemuhle), Steve Pfaff (Daylab), Itze Greene (Polaroid Corporation), Stephanie Morey (Freestyle Photographic), John Collins (MyFonts.com), Mac Holbert (Nash Editions), Bob Ware (Santa Monica College), Suzy Skaar, Alex Sandlin, Judi Weiss, Paul G. Joseph, and, most notably, Veronica Puleo Perelman (Verofoto), without whom this book would never have been written.

I'm grateful to have this opportunity to express my deepest gratitude to my brother Kevin Schultz (Schultz Bros. Photography) for shooting all the demonstration photos, and for his unflagging good nature.

I am deeply indebted to all those who allowed me to capture their keepsake moments and to include images of those moments within these pages.

Finally, my heartfelt thanks and appreciation to Victoria Craven at Watson-Guptill, and especially to Michelle Bredeson, a dream editor, for being such a pleasure to work with.

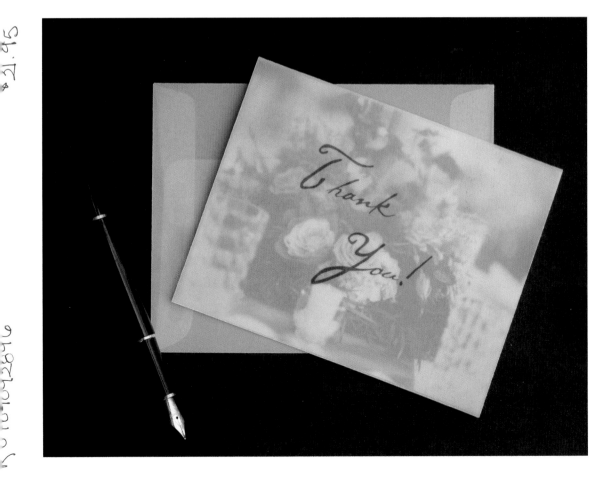

CONTENTS

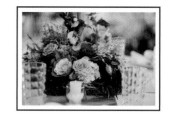

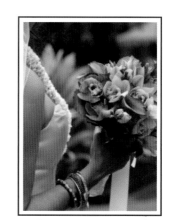

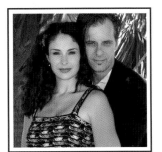

Foreword

This may sound incredibly trite and even a little sappy, but the photographic industry is one giant family. We attend the same conventions; many of us have worked together on the same projects and fundraisers; we go to the same rubber-chicken awards dinners; and we obviously share the same love for imaging. Just when we tend to think, "Been there, done that," a photographer comes along with so much passion and creativity that the "wow" factor is redefined and a new standard of excellence sets the stage—meet Barbara Smith!

And welcome to *The Art and Craft of Keepsake Photography*. Maybe a better title should be "Welcome to Barbara's World!" In Barbara's world, there's no such thing as just taking pictures. Once you understand how to create/capture the best possible images, your next step is to turn them into artistic stationery.

When I was a kid, photography was all about just taking pictures. It was that simple and, looking back, that boring! Dad took hundreds of slides, typically presented after each family vacation and annually at a family reunion, complete with slide projector, warped screen, and popcorn! In later years, the slide process morphed into prints stored in shoeboxes, and the presentation lost its fanfare. It's kind of sad to think of all those photos that hardly anyone saw.

Whether you're a professional or an amateur photographer, thanks to technology and a world filled with user-friendly prompts and processes, you now have the ability to create handmade invitations, thank-you notes, and even books and albums to share those special photographs with the world. The bottom line is that imaging has become personalized. Think about the impact of sending something as simple as a thank-you note that features one of your own images, and that looks professionally done. What a wonderful way to say "thanks," rather than hitting the card section of Walgreens!

In the pages that follow, Barbara is going to help you learn to think ahead when you first capture the image, then take you through the process of turning the image into something beyond just a picture and into a keepsake. Best of all, it's easy and it's fun!

Pay attention to Barbara's ideas, then add your own special creative ingredients, and each image you capture will suddenly have the potential to become more than just a picture.

If a picture is worth a thousand words, then, with the right equipment, just a little creativity, and the information in this book, you have the same power that Shakespeare did.

Skip Cohen
President, *Rangefinder Magazine*/WPPI

Skip Cohen and Barbara Smith. (Photo by Bill Hurter)

Introduction

As a very young girl, long before the advent of warehouse-size office supply stores, I loved to walk to the local stationery shop and drift through the quiet aisles. I was drawn to the scent, the feel, and the colors of paper, and to the seemingly endless variety of writing tools and accessories. It seems only natural that I would cultivate that appreciation and, as an adult, come to utilize those same materials in my work. At the same time, I began developing an interest in photography. My father and my brothers are photographers, so you could say photography's in my blood. Weddings, pregnancies, and births within my family gently nudged me in the direction of wedding and portrait photography.

Just a few years ago, I recognized the natural affinity between my two passions—photography and paper arts—and began creating custom invitations, announcements, and photo albums that feature my images. To my surprise, no book existed offering instruction on how to combine the two art forms effectively. *The Art and Craft of Keepsake Photography* fills that void.

A keepsake is commonly defined as something kept or given to be kept as a memento. In this book, you'll learn how to shoot dynamic images of life's richest moments and transform them into unique mementos—cards, announcements, invitations, albums, and more—that share the story.

This is not an introductory book on photography, nor is it intended to be comprehensive. You should be comfortable with the fundamentals of photography and the function of your camera. But

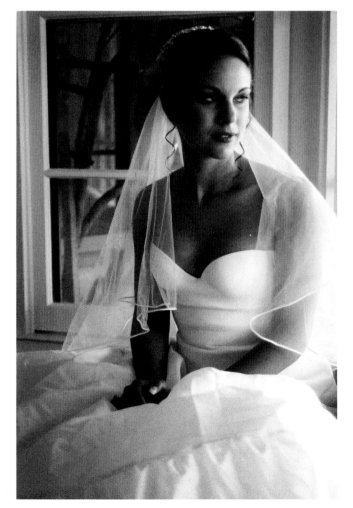

Chapters 1 through 3 will guide you in developing your photographic style, offering tons of tips and techniques for capturing memorable photographs.

don't worry if you're not a pro. Although I've been selling my images in one form or another for over ten years, I still feel funny about calling myself a professional photographer. Quite honestly, I'm afraid I'll run up against a "real" pro who will ask me one of those typical photographer questions like, "So did you use rear-curtain sync or drag your shutter?" and I'll seem like a fool because, truth be told, I don't know how to do either of those things. This book is for both amateur photographers *and* pros who want to expand into designing custom stationery to showcase and share their images.

Simplicity is the essence of my creed. I shot each of the images in this book, and about 90 percent of them were captured with one camera, one lens, and available light. I recently picked up a book written by a photographer who carries a carload of equipment to each event! I carry my equipment in a camera case small enough to take onboard a plane. I don't want to worry about or lug extraneous, heavy

equipment, and I don't want to be distracted by the myriad technical aspects I might encounter. I prefer to work with what I have, and make what I have work.

Don't get me wrong—I love technology—it makes life so much easier. Technology brought us high-speed film (so we don't always need cumbersome lighting equipment), the zoom lens (so we don't have to change lenses so often), and Adobe Photoshop (the photographer's best friend—a virtual custom lab in a box). The advent of digital fine art papers is a technological marvel, as is the ability to locate and purchase art supplies and handmade papers from around the world via the Internet.

Our intention in creating the photographs and keepsakes detailed within these pages is to communicate. Keepsake photography is authentic and strikes a chord within us. Although some of the shots in this book are posed, they communicate emotion. That is our deepest purpose here. Wedding photography in particular demands that we capture images that do

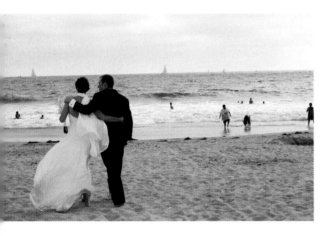

In Chapter 4, "Turning Your Photos into Works of Art," you'll learn to use the magical powers of Photoshop to crop, enhance, and remove details that would detract from an otherwise exceptional shot.

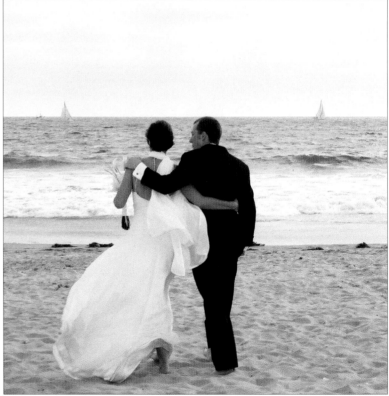

justice to the importance of the day and that will endure as family heirlooms.

Taking photographs that interpret and express your creative vision is only the first step in creating unique keepsakes. By complementing the images with beautiful papers and typography, and even adding embellishments such as fiber or found objects to your stationery, you can take that vision to another dimension. Feel free to experiment!

Each of the projects detailed within these pages can be adapted to your own process. Whether you use a traditional or digital camera, and whether you work on a computer and do your own desktop printing or employ the services of a copy shop, the results—although somewhat different—can be equally satisfying. Up until about two years ago, I used a copy shop to reproduce my 35mm images for use on custom stationery. Now I scan my photographs, digitally edit them in Photoshop as needed, and print them using an Epson printer.

In this book, I present many techniques that work for me, but I encourage you to choose the look that works best for you and communicates your style, then tailor the various projects to complement that style. Please bear in mind that digital photography and editing are specialized techniques that require initial instruction that is not offered here, although I do present lots of tips and tricks to get you started and whet your appetite to learn more.

And while all of the techniques and projects presented are straightforward and fairly simple, as with most endeavors, practice is the key to success. If you don't achieve flawless results right away, don't be discouraged. I hope you'll welcome the challenge and persevere because, to be perfectly honest, if I can do it, so can you!

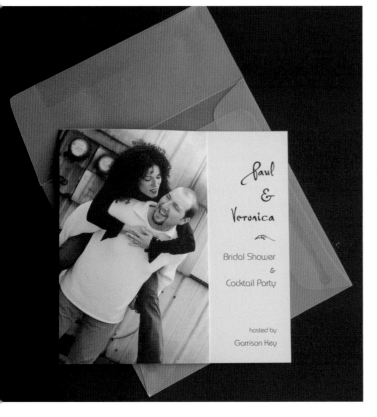

Chapter 6, "Creating Digital Layouts," and Chapter 7, "The Wedding Stationery Ensemble," include techniques and projects for creating one-of-a-kind stationery for any occasion.

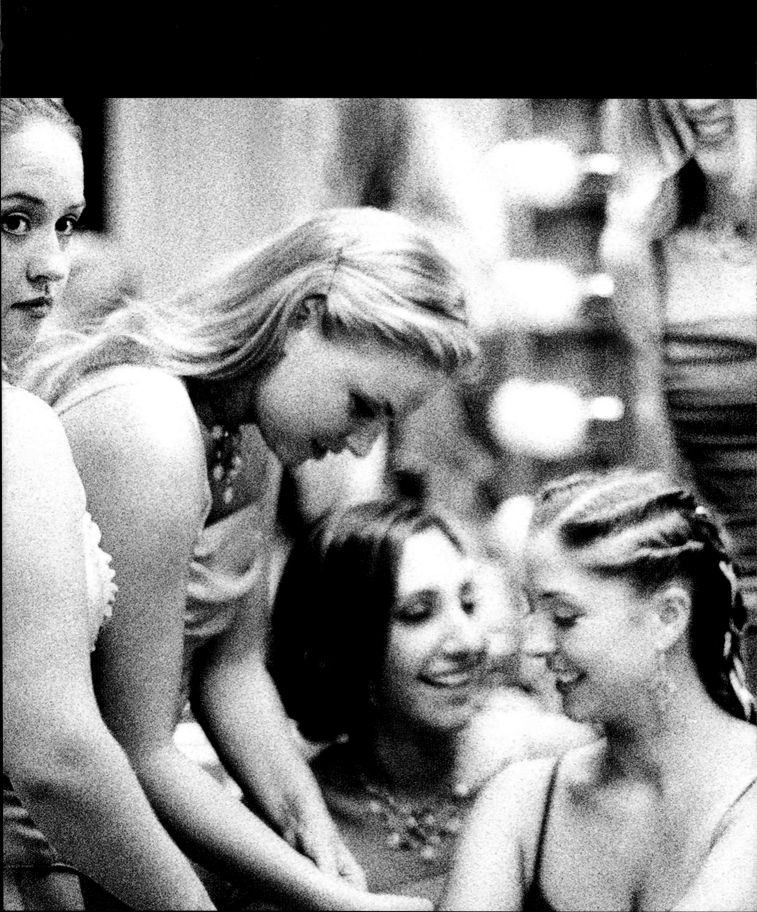

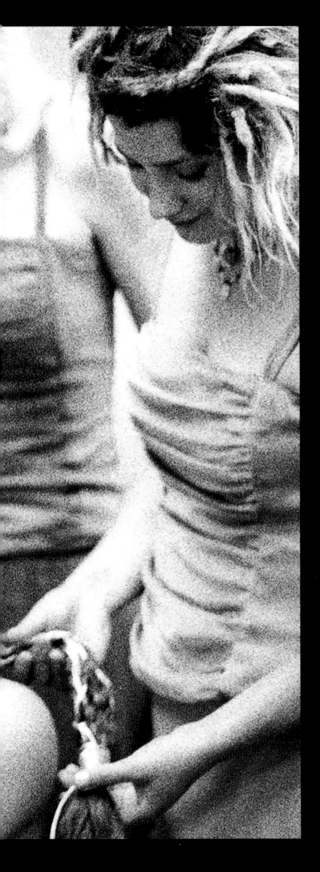

Chapter 1

THE ELEMENT OF STYLE

Although most of us were taught the same rules of cursive writing using identical sheets of grainy, lined paper, we each developed our own unique signature. Once we've learned the basics of almost any activity, over time that activity begins to reflect our individual style. Whether writing our names or taking a picture, who we are and how we feel is subtly conveyed. In creating keepsake photography, we want to communicate more than mere information—we want to capture images that evoke emotion. To do that, we must see rather than look, and interpret rather than document.

Defining & Refining Your Style

As we begin to pay more attention to the world around us—our neighborhood, our workplace, our home—we notice details we might ordinarily overlook, such as shapes, textures, patterns, lines, and movement. We notice shadow and light, angles, and scale.

You can hone your particular style by paying attention to, and being inspired by, what others have done. Study billboards and magazines to determine what types of images consistently draw your attention. Choose words to describe that look. By previsualizing how you would like your images to look—be it sophisticated, painterly, avant-garde, airy, sun-drenched, or moody—you can then set out to achieve that effect through the use of particular types of film, cameras, exposures, and lighting.

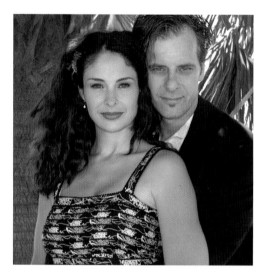

❧ TIP

Previsualization, a practice popularized by Ansel Adams, refers to the act of imagining the final image, then setting up the shot with that result in mind. Get in the habit of taking a quick mental picture before pressing the shutter button. How can you make the shot more interesting?

The photo on the right documents the couple; the one below interprets their relationship.

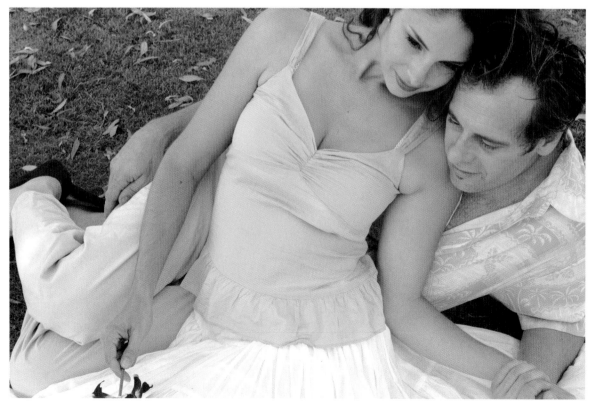

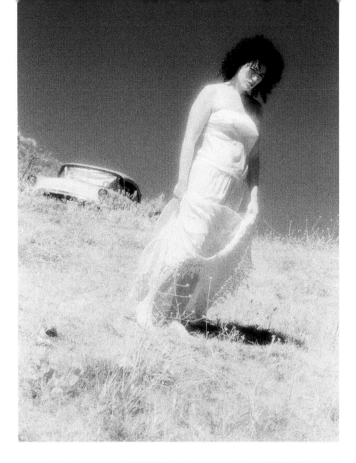

This moment was captured at high noon as the bride cut across an empty lot on the way to dress for her wedding. The angle, the classic car in the background, and the use of infrared film give it a creative interpretation.

CREATE A VISUAL JOURNAL

Tear pictures out of magazines, collect paper swatches, and enjoy the simple childhood pleasures of cutting and pasting by keeping a visual journal of your observations. Attach fiber and/or three-dimensional objects, then add commentary with colored pencils, calligraphy pens, or markers. As you immerse yourself in the creative process, ideas will spring forth effortlessly, seeking and finding expression in your photographs, and in what you do with them.

Each page of my journal is a mini collage with its own theme or color scheme— a place to experiment with imagery, materials, and techniques.

Adding Pizzazz to Your Photos

You can add some dynamic effects to your repertoire to deepen the subtext of your shots, conveying subtle messages that cause the viewer to pause and reflect. Here are some tips for producing eye-catching photographs, but use them sparingly: Our brains appreciate a little diversity, but not to the point of distraction.

- Photos with the subject perfectly centered often lack interest. Shoot off center to add a sense of traveling forward, contemporary edginess, or spaciousness.
- When you set up a shot with strong lines in the background, try "raking," or tilting, the angle of the camera to add drama and a sense of movement.
- Create an interesting perspective by shooting from above or below your subject.
- Take advantage of architectural elements, such as a window, gate, or door, to frame your subject.
- When shooting people, include some close-ups of elements that add to the story, such as eyes, hands, accessories, or even clothing details.

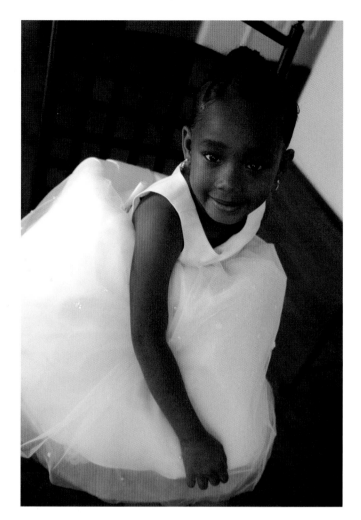

Photographing this little flower girl from above emphasizes her youthful anticipation.

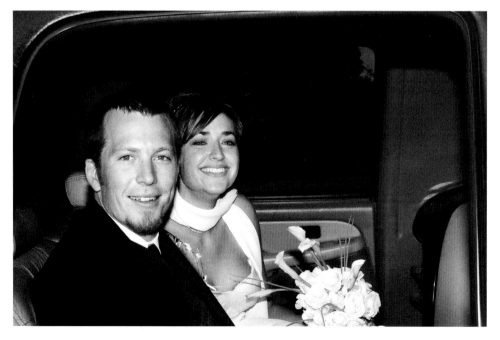

The limo window provides the perfect frame of the newly-weds on their way to the reception . . . and the rest of their lives together. By framing the subjects off center, the future is subtly implied.

OPPOSITE: Tilting the camera adds to the sense of movement created by the swirling gown and tide.

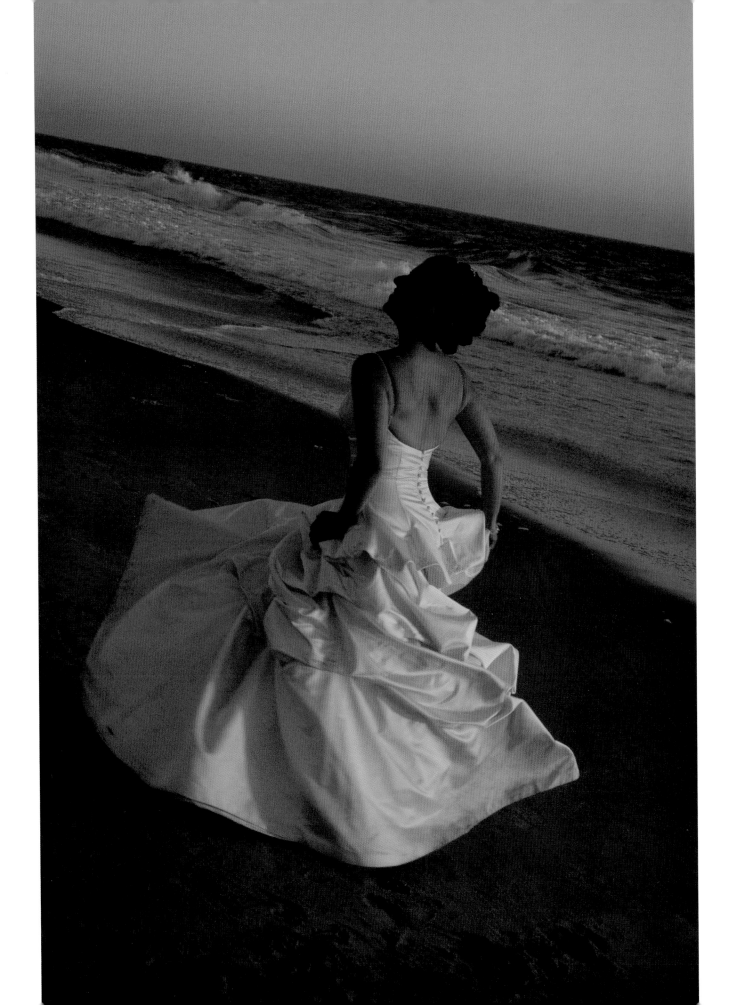

Capturing the Decisive Moment

In his book *The Decisive Moment*, photographer Henri Cartier-Bresson wrote, "To me, photography is the simultaneous recognition, in a fraction of a second, of the significance of an event as well as of a precise organization of forms which give that event its proper expression." Be attuned to your surroundings, keeping an eye out for these decisive moments. Weddings in particular are filled with them: the groom first sees his bride walking toward him down the aisle; a nervous giggle erupts as vows are being exchanged; the little ring bearer balks and the flower girl takes his hand; and, of course, the newlyweds exchange their first kiss as husband and wife. Anticipate these moments, be ready for them, and capture them.

The Roman philosopher Seneca said, "Luck is what happens when preparation meets opportunity." The same can be said of the decisive moment. The bride is walking down the aisle, and all eyes—and lenses—are on her. Confidently, you take the requisite shots. In your peripheral vision, a flash of white catches your attention, and you turn to see the mother of the bride as she dabs at a tear. Always prepared, you're using a zoom lens set to auto focus. Click!

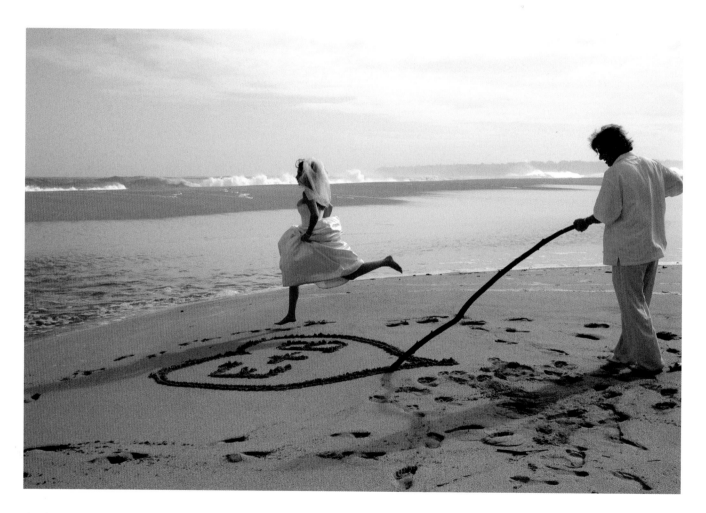

As the groom proclaimed his troth in the sand, the bride skipped by in a fit of light-hearted exuberance, and I was lucky enough to capture this decisive moment.

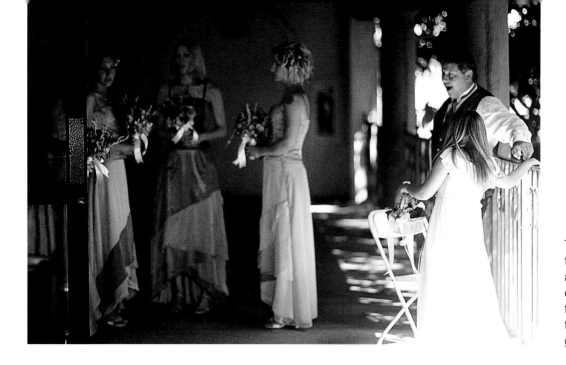

The bridesmaids are at the ready; the bride is about to emerge. The expression on Dad's face as he sees his little girl in her wedding gown is priceless.

BEFORE YOU SHOOT

Keepsake photography is a concept that combines left-brained attributes of logic and practicality with right-brained characteristics of impulse and creativity. The technical aspects of cameras, film, and other equipment are equally as important as vision, inspiration, and imagination in creating beautiful images and mementos. That's a lot to think about, and it can seem overwhelming. Making a list—and checking it!—is the best way to organize both tangible and intangible items before a photo session.

Left Brain Checklist

Before you set off for any photographic event, run through the following checklist to ensure that you don't leave anything behind:

- ☐ Camera(s)!
- ☐ Peripheral equipment such as lenses, reflectors, strobes, and tripod
- ☐ Film and/or memory cards
- ☐ New or freshly charged batteries
- ☐ Miscellaneous: notebook, tape, clamps, fabric for draping, alternative cameras and film, changing bag, filters, marking pen, and a stool for added elevation

Right Brain Checklist

Before each sequence of shots, previsualize the end result. Ask yourself the following questions and make sure the answers reflect your creative intention:

- ☐ What is the feeling I want these images to convey?
- ☐ Which film should I use, or will I be shooting digitally?
- ☐ Which settings will give me the look I want?
- ☐ Is my ISO setting correct?
- ☐ Is my exposure mode—auto, program, shutter priority, aperture priority, or manual—correct?
- ☐ Is my focus mode correct?
- ☐ Do I need to reset anything from my last session?
- ☐ Are my batteries new or freshly charged?

Once you're organized, your intuition can take over, your artistic impulses will have free rein, and you'll be ready to trip the shutter when the right moment arises.

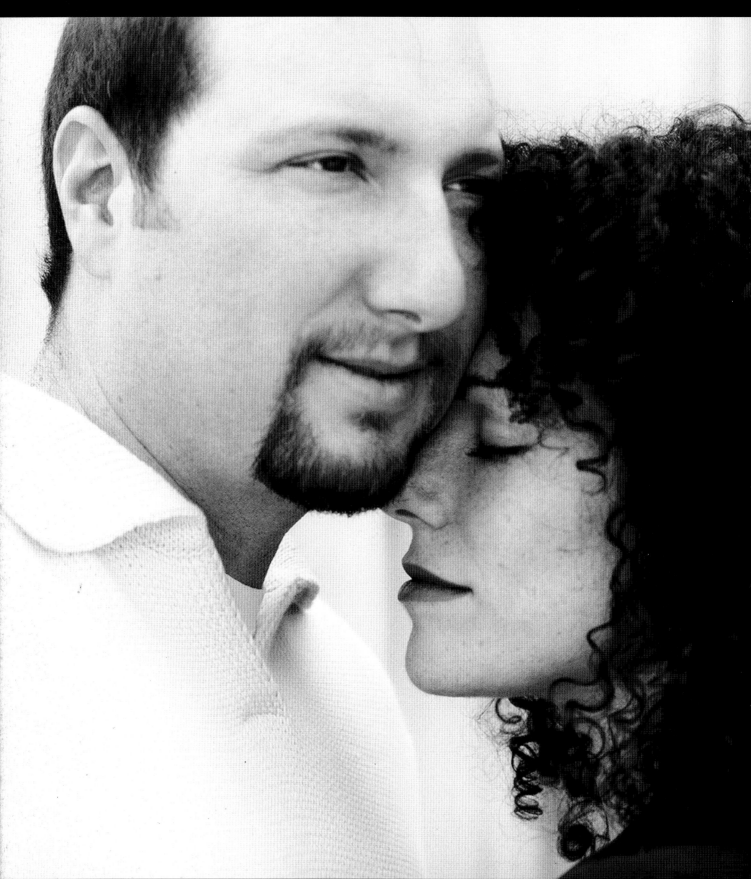

Chapter 2

PHOTOGRAPHING THE ENGAGEMENT & SHOWER

During the engagement photo session, the photographer and the couple also "engage" in a relationship. Ideally, it's a relaxed situation: Everyone gets to know each other a little better, some photos are taken, and the photographer feels like a trusted friend of the family by the time the big day rolls around. The bridal shower is another wonderful opportunity to strengthen your relationship with the couple—or just to have fun! Bridal showers may be casual or formal, high-brow or, well, downright raunchy. Traditionally women only, many showers now include men as guests. Whatever the tone, choose a complementary photographic style.

The Engagement: Capturing the Couple

Whether or not you're the "official" wedding photographer, don't miss the opportunity to capture the romance and anticipation in the air in the months preceding the wedding. More than any other photo op, the engagement session is *all* about the relationship. Whether the bride and groom are playful or sedate, romantic or cerebral, outrageous or traditional, there's a key element that drew this couple together, and you'll see it in the way they interact. Your photographs should capture the essence of their unique relationship.

As always, previsualize the look you want to achieve. Keep in mind the relationship between ISO, shutter speed, and aperture in determining the proper exposure for that look. I generally choose a film that will best accommodate the lighting conditions, then set my camera mode to aperture or shutter priority, choose an f-stop or shutter speed, and let the camera determine the appropriate exposure. This allows me to concentrate on composition while interacting with the couple.

Most people feel somewhat uncomfortable in front of a camera, so offer *lots* of verbal encouragement, as well as gentle yet clear direction. People love to hear that they look good and are doing a great job, so be sure to tell them. Ask them how they met and became engaged. These two people are in love, and it will undoubtedly show. Ask them to look at each other, or to gaze off into the distance, and focus on their eyes. Of course they can look into the camera—just make sure they're touching, holding hands, or leaning in toward each other.

Get close; avoid background distractions by filling the frame with the couple. As long as they're genuinely engaging with each other, they'll be happy and relaxed, and this will come through clearly in the final images. A wide aperture will narrow the depth of field, throwing the background out of focus so that it doesn't distract from the subjects. And don't forget to shoot vertically as well as horizontally: A favorite picture frame or a particular wedding invitation layout may dictate the final orientation.

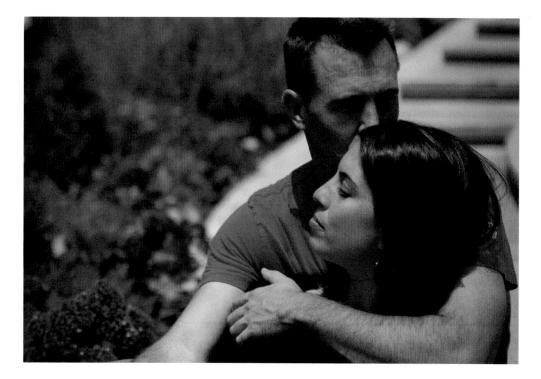

Using a very wide aperture (f2.8) dramatically shortens the depth of field. The resulting out-of-focus background contributes to the pensive quality of this engagement shot.

ACTIVITIES FOR COUPLES

Prepare a list of "activities" designed to set the couple at ease. Offer suggestions and then just shoot away. Often, the most magical shots come from those in-between moments when an unexpected gesture or interaction tells the true story at the heart of the relationship. Try to capture a sense of tenderness mixed with spontaneity.

Ask the couple to:

- Lean against each other
- Nuzzle into one another
- Gently lean one profile, with eyes closed or cast down, against the other's full face with eyes open
- Straighten one another's hair or collar
- Roughhouse or dance
- Try to pick each other up

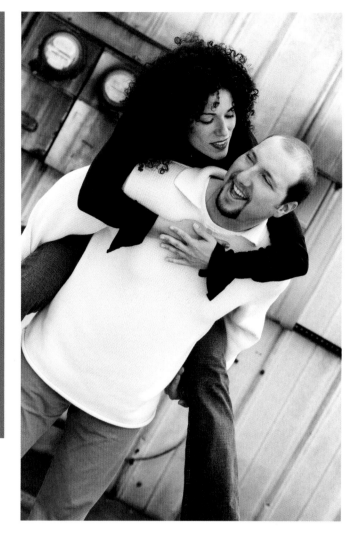

Tilting the camera adds a dynamic sense of motion to this playful shot.

Their body language speaks volumes about this couple's intimate connection.

Location

You may decide to shoot the engagement session in an environment that reflects the personalities of the soon-to-be newlyweds, as well as the special connection between them—a park, the beach, even a busy city street. Or perhaps the couple has a location in mind that has special significance to them: where they met, where they went on their first date, or where he (or she) proposed. Alternatively, a casual indoor setting lit solely by diffused or indirect sunlight is sure to result in some softly romantic compositions with just enough texture and detail. Place an easy chair next to a window and allow the pair to get cozy, then capture the expressions and gestures that bespeak their love. Of course, studio shots afford the most control in terms of lighting and fewer distractions.

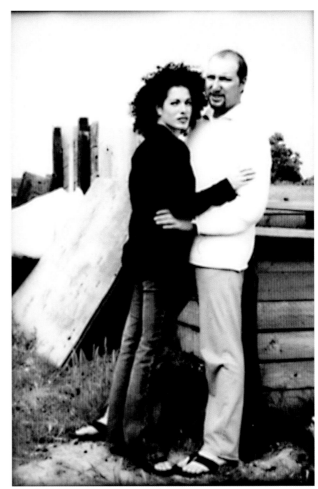

An unconventional outdoor setting, casual clothing, and clear body language—telling details that add up to a story. Cross processing (see page 60) gives the photo an avant-garde effect.

Everyday clothing, natural light, and a neoclassical environment give this studio shot a look of casual elegance.

Clothing

The style of clothing may dictate the tone of the session. Comfortable clothing that allows freedom of movement lends itself to playful roughhousing or riding piggyback, and if you're going to be designing custom stationery, T-shirts and jeans may be perfect for a casual save-the-date card. On the other hand, a shower or wedding invitation might call for something more sophisticated or formal, even an outfit that hints at wedding attire. Ask the couple to wear solid-colored clothing, as patterns can be distracting.

Simple, coordinated clothing and a casual, relaxed pose result in an engaging portrait.

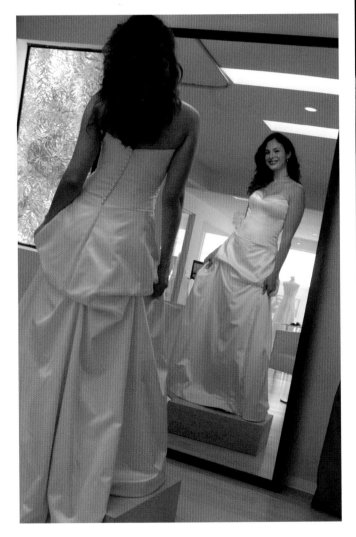

If you took pictures of the bride-to-be as she was being fitted for her wedding gown, one of those images might be just the thing for the bridal shower invitation, but only if the bride isn't intent on the element of surprise come her walk down the aisle. At the very least, they're certainly keepsakes!

❧ TIP

At the end of the engagement session, present the bride-to-be with a photo album that can also be used as a guest book at her bridal shower, then filled with photos that capture the fun. Show her a sample of a completed album if you have one. (See Chapter 8, "Guest Books & Albums," for projects.) And if it's not already part of your wedding package, include a certificate or discount coupon for a bridal shower shoot.

ANNOUNCEMENTS & INVITATIONS: WHICH PHOTO TO USE?

Now comes the really fun part—choosing the perfect image for invitations, save-the-date cards, and announcements. The final decision will be up to the couple of course, but they may ask for your input. If one of the photos taken at the engagement session is to be included in a newspaper announcement, it's particularly important that the faces of the betrothed be close together. The image often ends up being cropped radically because of space constraints, and the couple can appear to be nothing more than friends if their heads are far apart.

Bear in mind that a portrait is not the only type of photograph suitable for wedding stationery. A generic shot featuring interlocked hands and the engagement ring or an artistic angle that doesn't really show identifiable facial features could be just the right thing for an invitation or save-the-date card. Certainly not every couple wants to feature a picture of themselves. I urge you to shoot your own collection of "stock" photographs—flowers, still lifes, seasonal themes, wedding rings, churches, wedding cakes—that perhaps can also be transformed into painterly images through the use of Polaroid processes (see page 69).

Suggest the use of a favorite shot or shots as the basis for save-the-date cards, bridal shower invitations, and wedding invitations, and provide samples—a perfect opportunity to enhance your role as not only this couple's personal photographer but as their custom stationer as well.

The Bridal Shower: Capturing the Fun

Whether it's an afternoon tea, coed cocktail party, or girls' night out, the bridal shower is all about fun. Mugging for the camera is definitely allowed here, so get into the swing of things, circulate, and click away. While most of these images are more likely to be snapshots than works of art, this event is definitely something the bride will want captured for posterity.

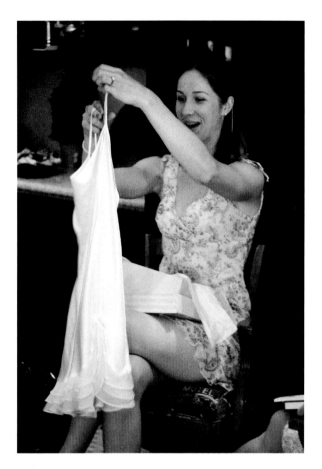

The look on her face says it all. You can almost read the mind of this bride as she envisions herself in this lovely lingerie while on her honeymoon.

A surprise appearance by the groom with an armful of flowers caught the guest of honor (and the photographer) off guard—a priceless moment nevertheless.

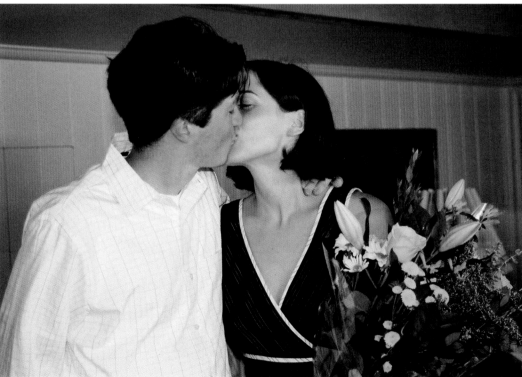

Scene Setters

A fair amount of time, energy, and expense has usually been spent by the hostess, or hostesses, in honoring the bride in this traditional rite of passage. Before the festivities begin to unfold, preserve the details by taking some thoughtfully composed still life shots of the decorations, table settings, centerpiece, and cake.

Early on, take some scene setters such as welcome balloons or signs, table settings, close-ups of the invitation and special party favors, the personalized guest book/album at the ready, and, eventually, the table stacked with beautifully wrapped gifts.

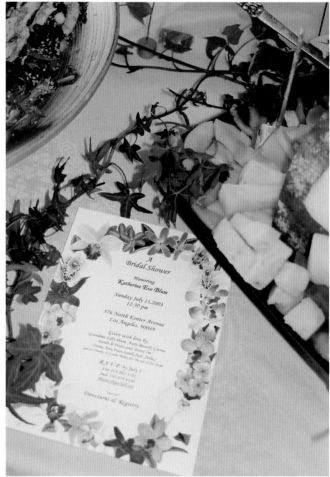

Activities

The opening of gifts is typically the highlight of the shower. In addition to the look on the face of the guest of honor as she opens those special gifts, be sure to capture some telling reaction shots from onlookers.

The meal, usually followed by dessert, is another highlight of most showers. Take plenty of group "table shots"—but no one in the act of eating, please! Many showers include party games and even skits. The groom may also make an appearance. Shoot lots of candids, especially of the bride with each of her friends and family members.

Whether totally candid or spontaneously posed, shower photos like these bespeak warm and genuine friendship.

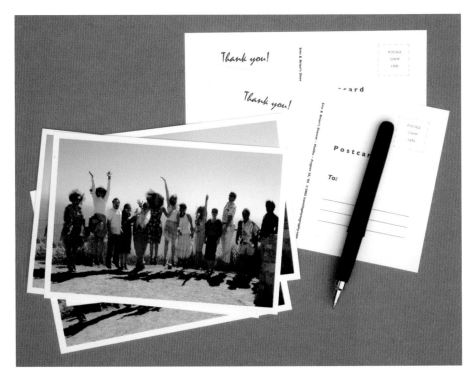

This coed shower included a hike to a lookout with a breathtaking view of the Malibu coastline. With this zany group, a postcard featuring the resulting photo provided the perfect thank-you card.

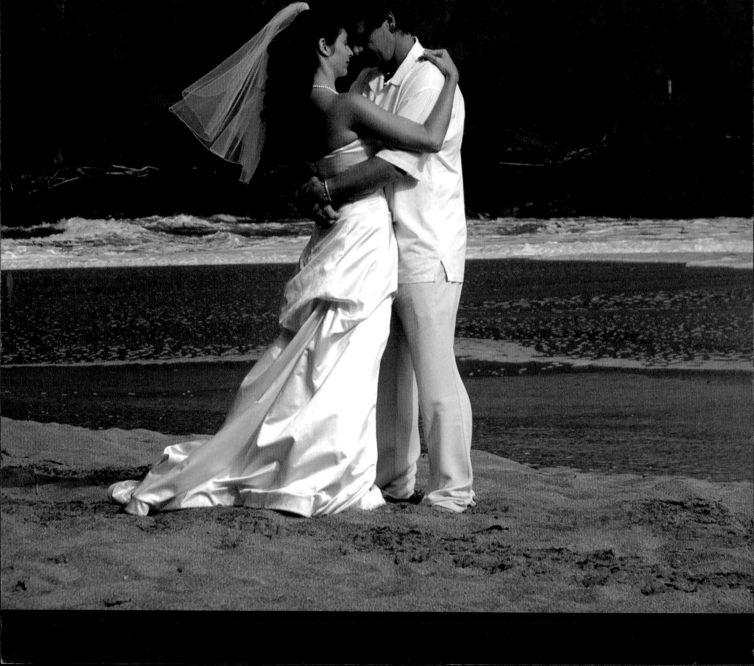

Chapter 3

PHOTOGRAPHING THE WEDDING

Use your camera to tell the full story of the wedding day from beginning to end. There will be countless unanticipated moments and details worthy of recording. Candid shots of children, thoughtful studies of older people, spontaneous interactions between members of the wedding party, even the mode of transportation—be it limousine, vintage automobile, or horse-drawn carriage—all provide fodder for some very special images. It's been said that God is in the details: Draw on them to add layers of interest and depth to your take on this most special event.

Preparing for the Shoot

No other event offers such an abundance of fabulous photo ops as a wedding. Emotion runs high and is inherent in every shot; people are looking their very best; classic architecture and scenic backgrounds abound; flowers, tuxedos, and gorgeous gowns are plentiful. Keep your eyes open and your senses attuned to authentic moments.

Here's the perfect occasion to flex your photographic muscles. If possible, use two cameras, and load one with black-and-white film. If you're using a zoom lens, vary your focal length. I attach a 28–80mm zoom lens to one camera and an 80–210mm to the other. These variables allow creative options when it's time to select favorite shots for thank-you cards, framing, and, of course, the wedding album.

Wedding photography is a highly skilled profession, and a wedding is an emotionally charged and deeply important event. Unless you're a professional wedding photographer, it's best not to assume responsibility for shooting an entire wedding. You can still get wonderfully evocative shots—close-ups of the bride and groom holding hands or with their arms wrapped around each other, a romantic kiss, details of the wedding gown, the bouquet, the wedding cake. Today's wedding photographer's "must-have" shots, as detailed within this chapter, are easily captured by the observant nonprofessional when approached with a discerning eye for detail and composition. In fact, shooting from what may seem like a less than perfect vantage point can add to the photojournalistic quality of the image and thereby enhance it. If there is a professional photographer on site, be it in the dressing room, near the altar, or at the reception, be very careful not to compete or interfere with his or her shots.

❧ TIP

Some professional wedding photographers include a clause in their contract with the bride and groom prohibiting or limiting the taking of photographs by other photographers. If you're not the pro, be sure to check into this ahead of time!

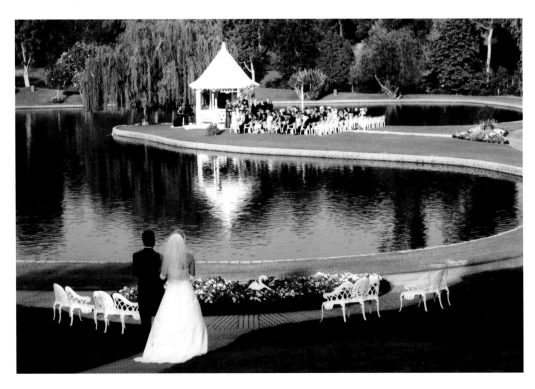

This unexpected vantage point proves that you don't have to be the official photographer to get the perfect shot.

Getting Ready

The bride and groom, sequestered from one another, may dress for their wedding at home, in a hotel room, a church basement, a country club locker room, even a boat. They are usually accompanied by parents, bridesmaids, and groomsmen, and possibly attended to by a hairdresser and/or makeup artist. Hustle, bustle, and lighthearted fun mingle with nervous anticipation. It's my favorite part of the day. The preparations of the women in particular often evoke the feeling of an Impressionist painting.

You'll most likely encounter a combination of low natural light coming in through the windows along with room lighting, usually tungsten lightbulbs, both of which can provide pleasing effects. To avoid using a strobe, I load fast film (Kodak T-Max P3200 rated at 1600 to lessen the contrast) for an artistic, soft, grainy look. I prefer shooting black and white in this situation, then switching to color for the ceremony. The transition reminds me of *The Wizard of Oz*, where Dorothy loses consciousness in black-and-white Kansas and awakens in the Technicolor world of Oz. If I do shoot color film for the preceremony shots, I invariably choose Fujicolor NPZ 800.

Here is a situation that inherently lends itself to creative interpretation. Today's "getting ready" shots, as they're called in the trade, are the equivalent of classical paintings. Shooting in natural light softens backgrounds and adds an aura of intimacy to the details of preparation, wedding accessories, and the helping hands of special friends and family members.

Candid photos, particularly of the bridesmaids or mother of the bride helping to button the back of the wedding gown, the bride putting on her shoes, or even posing coyly in her bustier, are most effective here.

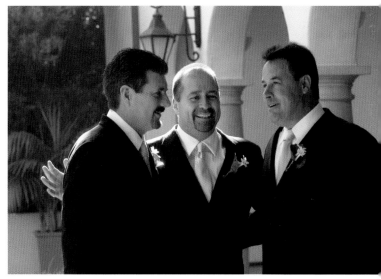

The easy camaraderie between the groom and his groomsmen is obvious in this candid shot caught shortly before the ceremony began.

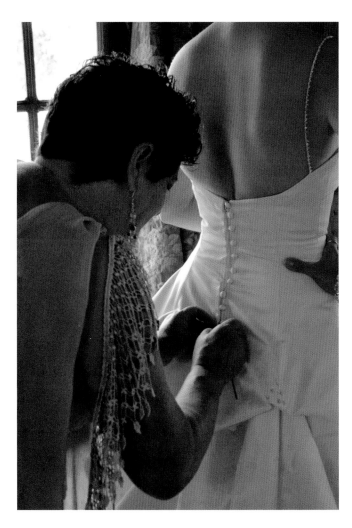

Any bride lucky enough to have her mother helping to button her gown will savor this special moment.

SHOT LIST: THE BRIDE GETTING READY

When going on a photo shoot, it's a good idea to carry a list of shots you want to try to capture. If you plan to shoot a lot of weddings, you might want to create a little booklet of laminated lists appropriate to each segment of the event. Punch a hole in the top corner of each page and use a metal loose-leaf ring or keychain to hold them together. Here's my list of getting ready shots:

- A "still life" composition of shoes with flowers or jewelry
- The wedding gown on its hanger
- Details of the wedding gown
- The bride . . .
 - . . . as her hair is being styled and/or makeup is being applied
 - . . . in her lingerie—these shots may not make it into the wedding album, but the groom will surely treasure them!
 - . . . slipping into the wedding gown and it being buttoned
 - . . . putting on special jewelry (with Mom helping?)
 - . . . putting on her shoes
 - . . . putting on her veil
 - . . . in veiled silhouette
 - . . . peeking out the window right before departing for the ceremony
 - . . . getting into and out of the limo
- A sequence of shots: something old, something new, something borrowed, something blue

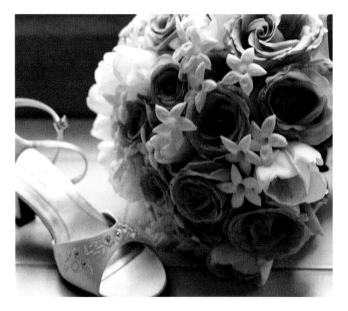

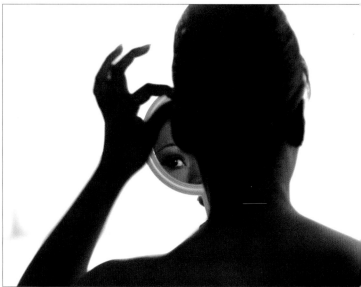

The bride's wedding shoes and bouquet are important details to preserve. Natural light coming in through a window enhances the simple composition.

Every hair must be in place on this special day! Exposing for and focusing on the image in the mirror helps to create a standout shot.

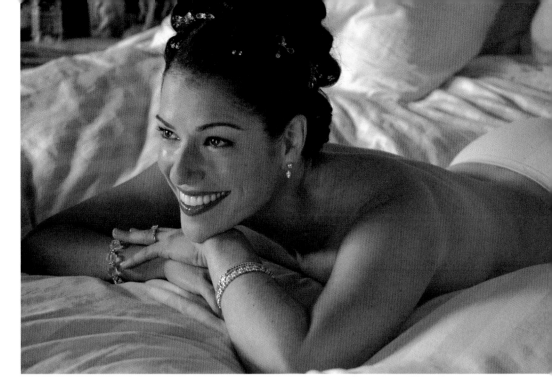

The hair is done, the makeup is applied, and the jewelry is in place. In moments this bride will step into her wedding gown, but for now she enjoys a lighthearted photo op.

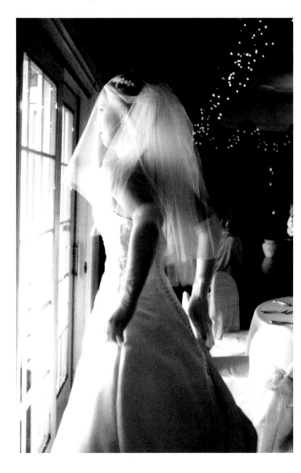

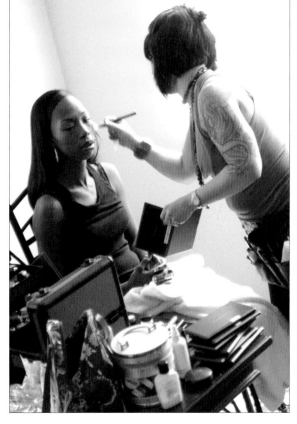

This is *the* decisive moment. In seconds, all eyes will be upon this radiant bride.

A photo of the sister of the bride getting ready is sure to be treasured as a reminder of the day's preparations and excitement. Overexposing this shot and tilting the camera create a fun, edgy look that perfectly suits the subject matter.

SHOT LIST: THE GROOM GETTING READY

Call me a chauvinist, but to me, the guys getting ready somehow doesn't have quite the same poetry as the women. Nevertheless, the sight of the groom hanging with his best buds before the wedding has its own touching charm, and those male customs—shaking hands and high fives—tell a story of their own. Here's a list of some desirable shots:

- Guys shaving or combing hair
- Fixing each other's tuxedos/ties
- Pinning on boutonnieres
- The groom and his best man
- The groom and his father

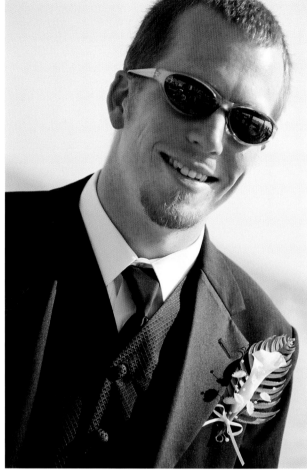

Ready or not . . . the quintessential cool groom. The tilted angle adds an edgy, hip aspect.

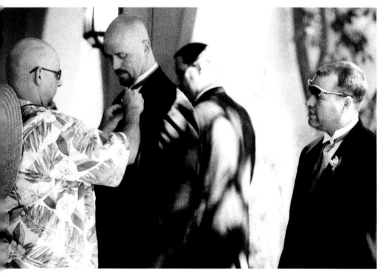

A grainy photojournalistic approach achieved through the use of fast black-and-white film.

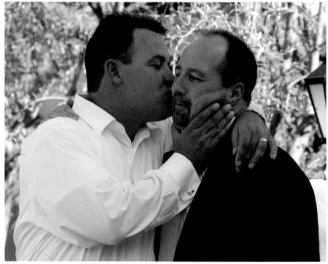

Many men aren't comfortable talking about their feelings. This shot of the best man laying one on the groom is worth a thousand words.

Setting the Scene

Your photographs should tell the story of the day as it unfolds. If you have the opportunity, sometime before the wedding visit the location where the ceremony is to be performed to scout potential setups and backgrounds. By doing that, on the day of the event, you'll know just where to find evocative scene setters. Any of these types of shots might be enhanced by the use of infrared film, or postproduction tinting or cross processing. (See Chapter 4, "Turning Your Photos into Works of Art," for ideas and techniques.) Just remember not to overdo it—a little creativity goes a long way here.

SHOT LIST: SETTING THE SCENE

Here are some scene setters I always look for:

- A wide shot of the church, temple, or other setting where the ceremony is taking place
- If outdoors, the chairs being set up
- Floral arrangements lining the aisle
- A wedding canopy, or chuppah, being erected
- Flowers wrapped in paper or still in boxes
- Candles being lit
- Table settings, where I'll sometimes set up a still life with the wedding invitation
- Guests entering the house of worship
- The musicians

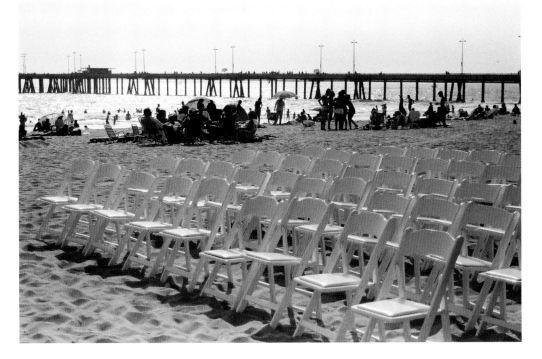

Almost anyplace can be the setting for a wedding. The amusing juxtaposition of the chairs set up for the wedding and the people just hanging out at the beach, oblivious to the wedding that is about to take place, tells a story.

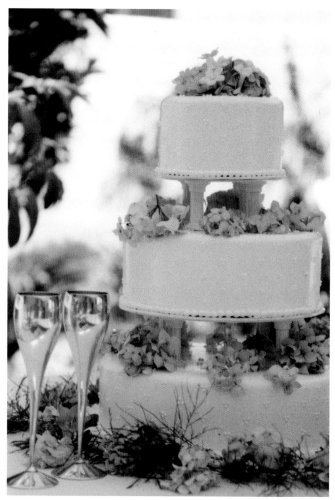

The simplicity of this image would make it a perfect candidate for a thank-you card for this or any other wedding.

RIGHT: This beautiful cake was transformed into a work of art by having the lab print the image on Kodak Portra Sepia Black & White Paper. (To tone an image digitally, see page 56 for instructions.)

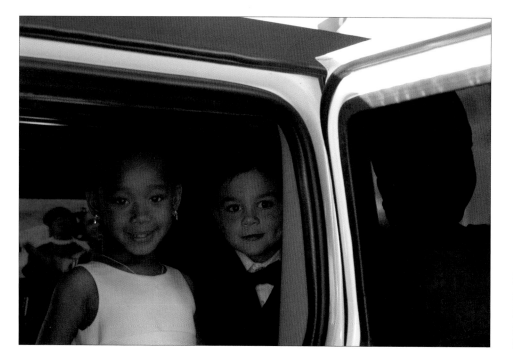

First limo ride! The window provided a frame for these lucky kids, capturing their preceremony excitement the moment the door opened.

The Ceremony

The stage is set; the sound of music is in the air; the bridal party stands at the ready. The excitement is palpable. Photo opportunities abound at both ends of the aisle: each member of the procession, the bride and her escort, the ceremony itself, and, finally, the bride and groom as they walk up the aisle as man and wife. The wedding photographer needs to be everywhere at once, but must always be careful not to draw attention.

Many houses of worship prohibit the use of flash photography during the ceremony, necessitating the use of a tripod or very fast film. More and more weddings are being performed outdoors, which is a boon for photographers—no lighting to worry about, and the click of the shutter doesn't sound quite so loud.

For optimal coverage, take a combination of long shots and close-ups, either by using two cameras or a zoom lens. Be sure to catch some reaction shots—the crowd as it turns to watch the bride coming down the aisle, the look on the face of the groom as he sees his bride coming toward him, the tearful response to vows being exchanged, the looks of pride, love, and elation.

SHOT LIST: THE CEREMONY

No matter where the ceremony takes place, there are a number of must-have shots every couple will want in their wedding album:

- The groom and the best man standing at the altar
- Each bridesmaid coming down the aisle
- The father of the bride giving his daughter away
- The exchange of rings
- The kiss
- At a Jewish wedding:
 - The bride and groom as they circle one another
 - The rabbi reading the *ketubah*
 - The bride and groom drinking from the wine glass
 - The groom stomping on the wine glass
- At a Japanese wedding, the ritual drinking of nine cups of sake
- At a Middle Eastern wedding, the giving of five symbolic almonds to the guests
- At a Hawaiian wedding, the bestowing of leis upon special guests

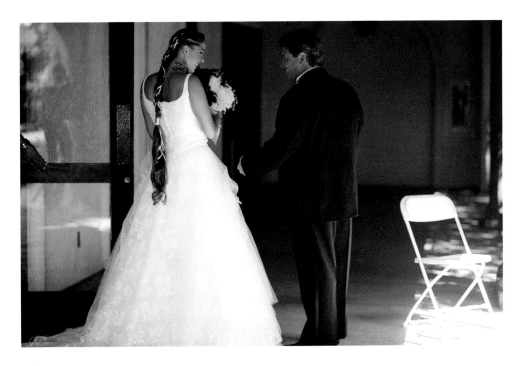

An authentic, decisive moment as father and bride prepare to walk down the aisle. It's interesting to note that this color photo is composed almost entirely of black and white elements.

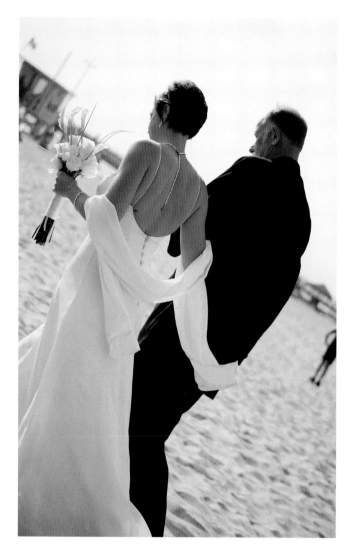

The back of the bride's dress and her accessories are shown to their best advantage. The lifeguard station, pier, and uninvited guest add to the photojournalistic quality of the shot, and the tilted angle adds a sense of motion.

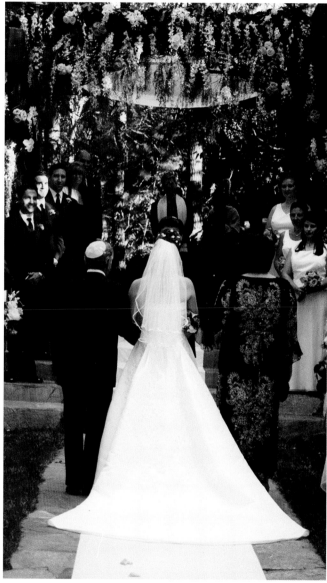

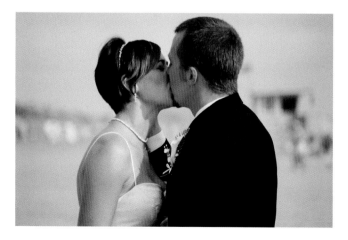

The rest of the world seems to disappear as the bride and groom exchange their first kiss as husband and wife.

A classic black-and-white photograph, perfectly composed, as the bride and her parents face the rabbi, groom, and attendants at the vine-covered altar.

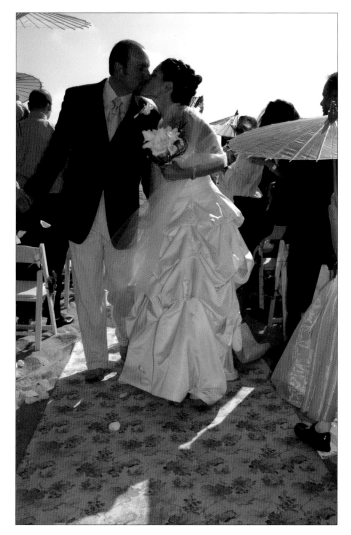

Even though I was not the hired photographer at this wedding, I was able to get this evocative shot from afar.

A spontaneous kiss on the way up the aisle as man and wife. The colorful umbrellas and fashionable attire are reminiscent of a Renoir painting.

Each faith has its own set of wedding rituals. In the Jewish tradition, the bride and groom each meet with the rabbi and witnesses before the wedding ceremony to sign the *ketubah*. If you're unfamiliar with a rite being performed and whether it's appropriate to take photographs, just ask beforehand. Black-and-white film helps convey the time-lessness and solemnity of these occasions.

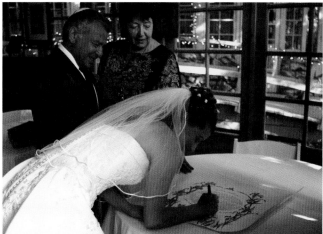

Group Shots

I have to admit that I'm not fond of shooting what are known as *formals*, but almost every newlywed couple feels the need to include these group shots in their wedding album, if only for their parents' sake. Wedding photographers are commonly handed a list of "must-haves" that include every imaginable grouping of family members.

A small number of elite wedding photographers have the cachet to refuse to shoot formals. I say "bravo" to those daring few. Group shots consume precious time, they're generally stilted and boring, and they're often difficult to assemble. If you're not quite at the point in your career where you can make such demands, at least enlist the aid of a family member of the bride or groom to "hunt and gather."

Catching a candid moment between posed shots produced a winning photo.

INFORMAL FORMALS

Here are some ideas for *creative* group shots:

- Try to catch the members of the group interacting spontaneously with each other in between poses. The resulting images will be a welcome complement to any posed shots.
- Run ahead of the group and shoot as they walk toward you.
- Shoot the bride and groom in the foreground with the rest of the group clustered off to one side behind them.
- Shoot the bride surrounded with groomsmen, and the groom surrounded by bridesmaids. These shots work especially well when everyone is having fun and even "mugging for the camera."
- Ask the group to form a huddle, crawl into the middle of it, and shoot upward.
- Shoot all the guys wearing sunglasses or holding cigars.
- Have everyone recline, lean on each other, and/or sit on the grass.
- Have the group form a "bouquet" and shoot down at them from a balcony or stair.
- Use architecture to enhance a shot. A window or door can provide the perfect frame. Situate the group along a stairway, under an arch, or leaning casually against columns.
- Focusing on the interaction between individuals or clusters, take several photos of the group, then reassemble them in a montage à la David Hockney.

OPPOSITE: The camaraderie and humor between the groomsmen and the bride add an element of fun to this shot.

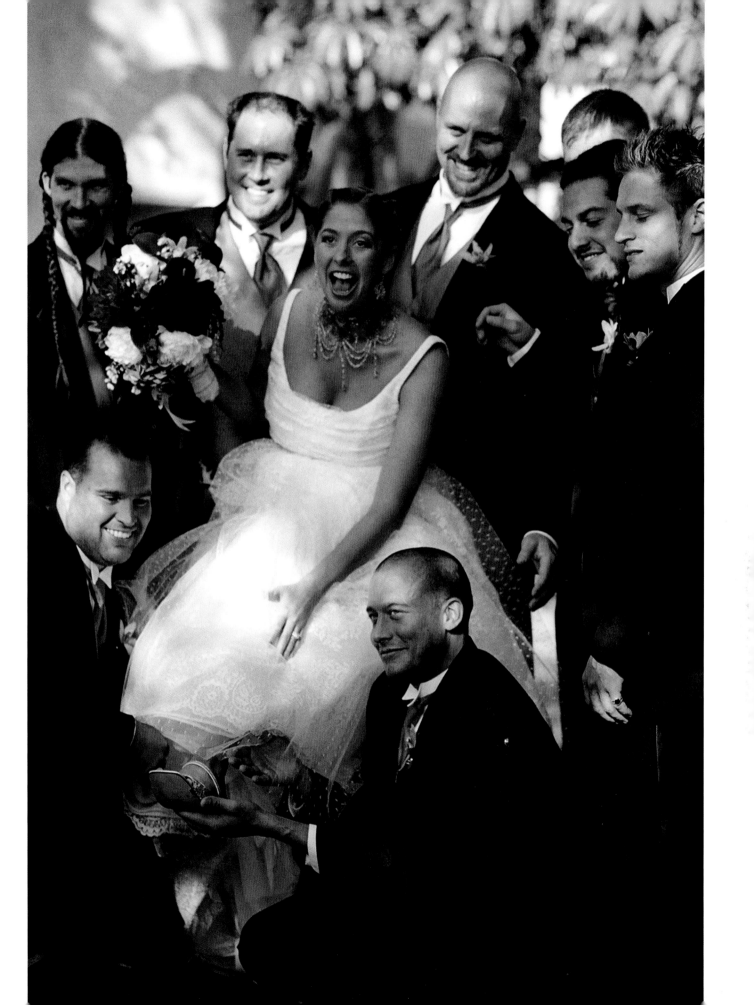

Romantics

Don't forget to take plenty of photographs of the happy couple expressing their tenderness and love for each other. Ask the bride and groom to pose for some of these photos, but also keep an eye out for candid moments to capture.

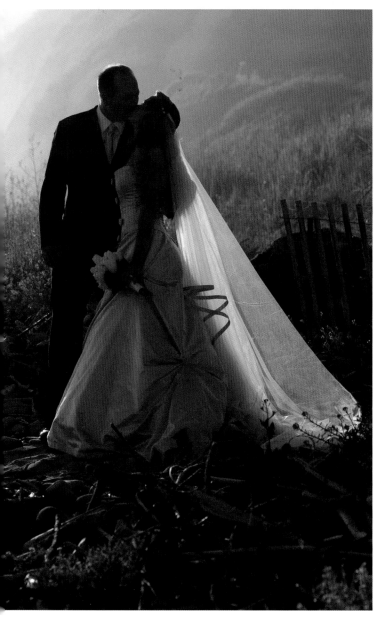

A backlit silhouette with the setting sun shining through the bride's veil, the driftwood, and the broken fence all add up to a softly romantic tableau.

In Jewish weddings, it's traditional for the bride and groom to spend a few minutes alone together right after the ceremony. This shot was taken from afar so as not to infringe on their privacy.

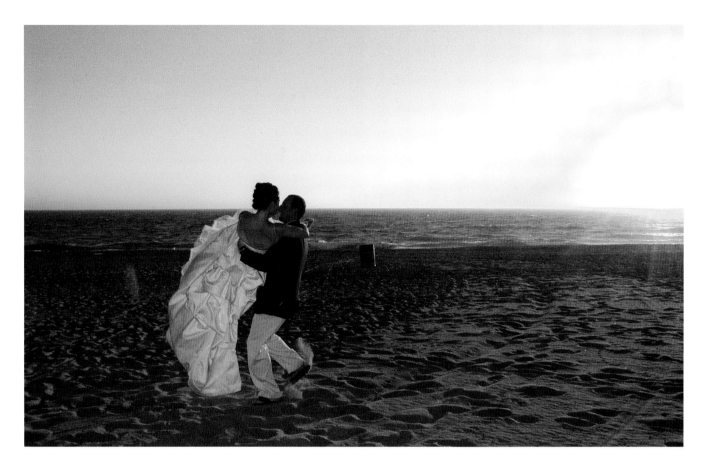

The flare from the setting sun combined with the blur of the sand being kicked up make this less-than-perfectly exposed shot perfectly romantic.

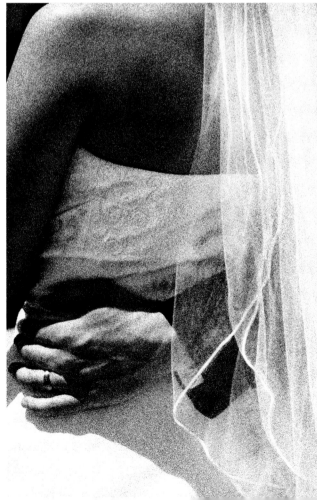

Adding "noise" and a sepia tone in Photoshop helps to create a timeless mood. This is a good example of the type of image to have in your personal stock library—you can use it again and again.

The Reception

By now, everyone is relaxed and happy. It's time to eat, drink, and be merry. You may want to use black-and-white film to impart an elegant, timeless quality to your shots. You'll most likely need to employ a strobe to supplement room lights and freeze the action. If there's a videographer on hand, take advantage of his or her lighting for some of your own shots.

In very low light situations, such as shooting on a patio at night, ask people to come into the light. The glow of a fire pit or a tiki torch can provide adequate illumination and add to the mood of the photograph. Use a strobe to bounce light off a nearby wall if possible. Use a tripod, a fast ISO, and a wide aperture.

The reception is a time of lots of activity, and you may want to capture a sense of movement in some of your photographs. Instead of using a strobe, try placing your camera on a tripod and setting a fairly long shutter speed. For special moments like the first dance or bouquet toss, keep your finger on the shutter release button to produce a sequence that tells a little story. Or use *synchro-flash*—combining a long exposure with flash, and moving the camera as you take the picture—to freeze the foreground and blur the background.

SHOT LIST: THE RECEPTION

As with the wedding ceremony itself, there are certain must-have highlights of the reception to capture. Be sure to include:

- The newlyweds' first dance
- The bride dancing with her father, the groom with his mother
- The toasts
- Cutting the cake
- The bouquet toss
- The garter toss
- Any special tributes or rituals such as, at a Jewish reception, the hora, or chair dance, and the cutting of the challah; children swatting the piñata at a Mexican wedding reception; or the famous Greek circle dance

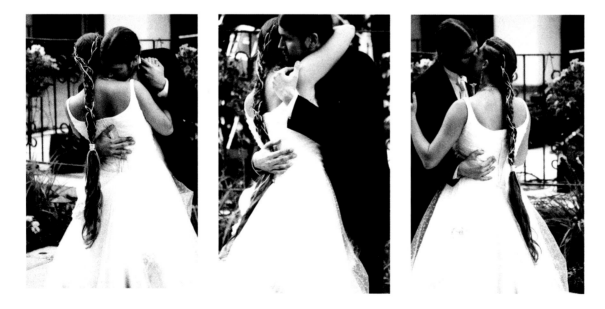

The traditional first dance . . . so romantic! Using black-and-white film helps to camouflage a busy background so that the eye remains on the newlyweds.

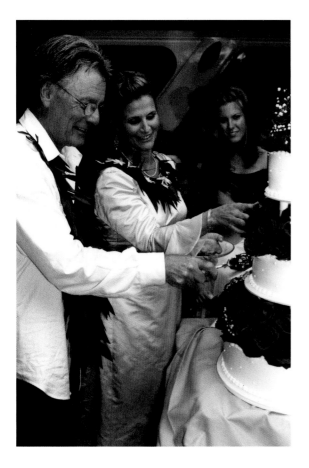

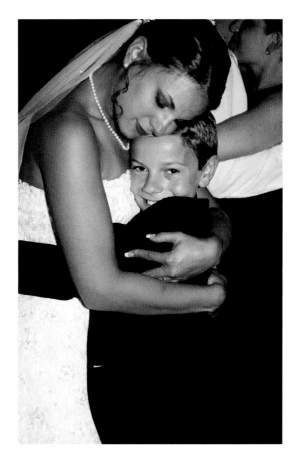

The cutting of the cake is a must-have shot for every album.

A tender moment between the bride and a young relative.

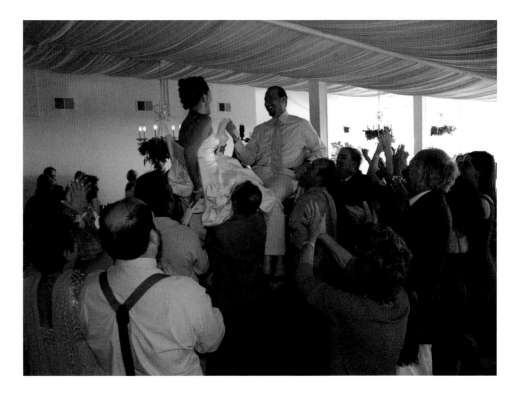

You can feel the fun and the excitement of the crowd as the bride and groom are lifted in their chairs for the traditional hora.

Chapter 4

TURNING YOUR PHOTOS INTO
WORKS OF ART

Any image you choose to create keepsake wedding stationery should be well composed, tell a story in one glance, and possess a fine art quality. Next time you're in a stationery store, check out the abundance of cards that feature a photograph. Each card is really a mini work of art; many are bought by people with the intention of framing them. The stationery you create may likewise be framed. If you have a photo you'd like to use that is *almost* there, if it just needs a little oomph, you can fix it in Photoshop, apply a digital fine art technique, or take it to an entirely new level through what is known as an alternative process.

Fine Art Techniques: Film Versus Digital

A passionate debate rages—and may never end—concerning so-called traditional versus digital techniques in fine art photography. At a recent photo expo, I met a dedicated photographer completely immersed in his specialty, the ambrotype, a wet-plate process dating from 1851. His images were stunningly beautiful. When I showed him my own "auratones," featuring a technique I've developed using gold leaf, he was impressed—until I told him they were created from digital prints, at which point his face stiffened. He went into a dissertation on the evils of methods he called easy, lazy, and impermanent. I countered with my own view that it's impossible to make such broad generalizations, that we're still in the infancy of digital photographic processes, and I mentioned the absence of toxic chemicals as one great advantage. At that point he thrust his hands in front of me, proud of the chemical burns and discolorations that proclaimed his seriousness as an artist. Clearly, I had in no way swayed his conviction.

With the advent of archival-quality fine art digital papers and pigment inks, there can be no doubt that art that has in some manner been touched by digital technology has a place in galleries and museums, and that place is rapidly expanding. As with all art, the power of the piece is dependent upon the proficiency, vision, and passion of the artist, not upon the materials used.

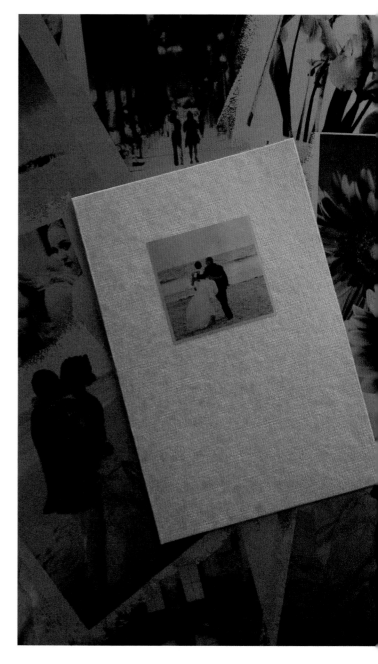

Although these images are "auratones," a technique not covered here, you can approach the effect with digital toning (see page 56). A wide border directs the eye inward and implies, "This image is special."

Digital Darkroom Techniques

The effects presented in this section lend themselves equally well to both film-based and digital methods, but the emphasis here is on a handful of very simple "digital darkroom" techniques.

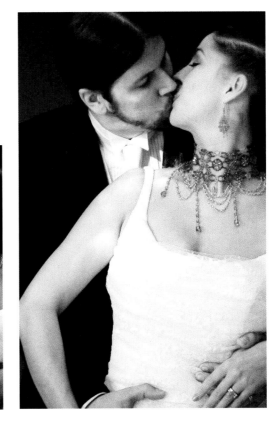

Spot coloring (see page 58) is a cool trick, and using Photoshop's zoom feature in conjunction with a very small brush allows you to precisely color even the most intricate details.

ADOBE PHOTOSHOP

The digital techniques presented in this section assume that you have a working knowledge of an image-editing software program. Since it would be impossible to provide instructions for every program out there, and since I, like most professional photographers, use Adobe Photoshop, that is the program used here to present some simple techniques.

Most moderately priced programs, including Adobe's Photoshop Album (for the casual photographer) and Photoshop Elements (for the somewhat more advanced photographer), allow you to perform straightforward tasks such as cropping, resizing, and correcting the overall appearance of a photograph. The full version of Photoshop, on the other hand, is an infinitely more complex program, used by novices, enthusiasts, and professionals alike, that allows you to do almost anything you can imagine to an image, and almost always in more ways than one! Naturally, the additional features make it more expensive. Once you're familiar with Photoshop, there are dozens of relatively simple and fun-to-do procedures that can enhance and complement your photos. Books and workshops abound. Go to Adobe.com for more information and to download free trial versions to see which program best suits your needs.

One of the most dramatic and effective methods of improving a photo is to crop it. By cropping, you can remove extraneous or distracting detail, enhance the composition, and direct attention to the emotional content of the image. Most photographers almost instinctively crop "in camera," meaning they carefully compose their shot before pressing the shutter release, but that can be tricky for less experienced photographers.

Dramatically cropping an image after it's been shot and then enlarging it may result in increased grain (or digital noise) and loss of sharpness. On the other hand, a very tight in-camera crop can also limit further usage. For example, if you shoot 35mm film and decide to transform one of those shots into a Polaroid image transfer (see page 70), portions of the original image will be lost due to differences in film formats. To allow for future options, take a wide shot as well as a close-up when shooting any given scene.

TRADITIONALLY . . .

Photographers use L-shapes in conjunction with proof prints to determine the most effective crop, and the final image is printed accordingly. To crop a proof print, cut two L-shapes out of a piece of card stock large enough to cover the proof print. Arrange the pieces in various configurations to isolate different areas of the image. As you slide the pieces closer together, the window gets smaller. When you find a pleasing crop, use a grease pencil to mark the proof and instruct the lab to use the marks as a guide when creating the final print.

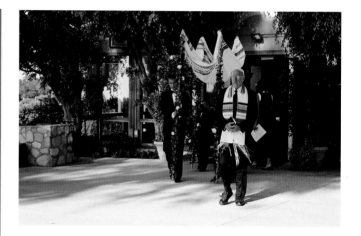

In this instance, the bride has decided she'd like to crop this photo to include just her sister, her cousin, and herself in order to create some special thank-you cards.

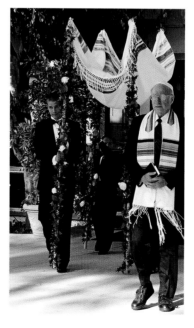

The effect of this shot of the rabbi and the wedding procession bearing the chuppah is diminished by the inclusion of the wedding coordinator in the background (above). Cropping the photo (left) eliminates that distraction, at the same time capturing and intensifying the mood.

1. In Photoshop, open the image that you'd like to crop.

2. Press the letter C to access the Crop tool.

3. Click-and-drag the Crop tool over the area you wish to keep.
- For a square crop, hold down the Shift key as you drag.
- To move the area of selection (marquee), place the pointer inside the bounding box and drag.
- To change the size while keeping the proportions the same, hold down Shift as you drag a corner handle.
- To crop and resize the image simultaneously, first enter a height, width, and resolution in the Options bar.

4. When you find a pleasing crop, press Return or Enter.

5. Save the file under a new name.

❦ TIP

If you pass your cursor over the individual tools in the Photoshop Toolbox, you'll notice a letter in parentheses after the name of the tool. As a shortcut, you can press that letter on the keyboard to access the tool.

Selecting the Crop tool in the Toolbox.

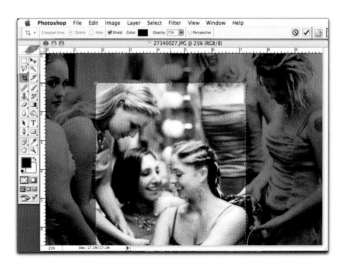

The light area of the photo within the dotted lines (the bounding box) is the portion of the photo that will remain after you complete the crop.

The Crop tool Options bar.

Black-and-white photography has recently been enjoying a surge of popularity, particularly when it comes to the big day—check out any wedding magazine for proof. There are lots of good reasons for converting a color image into black and white:

- Black-and-white images often seem more expressive than color, perhaps because the absence of color allows for more interpretation.
- Lines, forms, and shapes become more apparent, giving the photo a fine art appearance.
- A black-and-white treatment can give an image a photojournalistic quality, a hint of moodiness, that echoes the monochromatic images from old newspapers and newsreels.
- Transforming a color photo into black and white can lessen the distraction of a busy background.
- Black-and-white images, including infrared (see page 76), lend themselves to toning (see page 56) and tinting (see page 58).
- A black-and-white treatment improves the appearance of ruddy or discolored skin.

Digitally speaking, "information" means detail. In Photoshop, it's an easy matter to discard the color information of a photograph by simply resaving the file as a grayscale image, but the results are often dull and lifeless. Here is a far better method that will give you improved tonal quality, the hallmark of a good black-and-white photograph. I know of several ways to convert a color image to black and white in Photoshop, but this is my favorite because it's easy and, more important, it gives you a good amount of control over the outcome. Experimentation is key, as results will vary from one image to another.

TRADITIONALLY . . .

A black-and-white image is made from a color negative using special papers manufactured for that purpose. Several exposure and filtration adjustments may be required in order to achieve acceptable results.

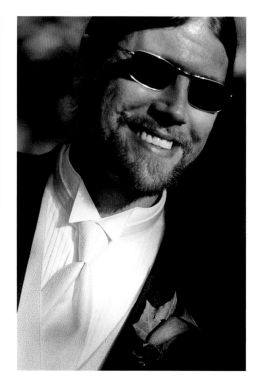

The groom's face is a little ruddy in this color photo.

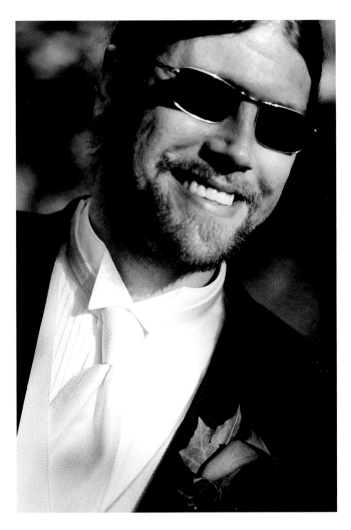

Converting the color photo to black and white fixes the redness and gives the image a more classic feel.

1. Open a color (RGB) image that you want to convert to black and white. If the image is in CMYK mode, change it to RGB (go to Image>Mode>RGB Color).

2. Go to Image>Calculations.

3. In the Calculations dialog box, both Source channels are usually red; change one to green.

4. Set Blending to Multiply. The Preview box should be checked; the Invert and Mask boxes should be unchecked.

5. Set Result to New Document.

6. Adjust the opacity to your liking, then click OK.

7. Go to Image>Mode>Grayscale, then Image>Mode>RGB Color. Save the file under a new name.

❉ TIP

Generally speaking, by saving a black-and-white image in RGB Color instead of Grayscale, you'll get better results—richer tones—when you print from your desktop. Your printer will use only black ink to print an image saved in Grayscale mode; it will use a little bit of every color ink to print in RGB mode.

The Calculations dialog box.

Black-and-white images are sometimes given a sepia tone to convey the look and feel of an old photograph. Toning with color adds an interesting quality and can also convey emotion—for instance, blue is considered a cool color and can communicate intellect, serenity, and depth, whereas red is a warm color signifying intensity, energy, and passion. You may also decide to tone an image to complement a certain paper, envelope, or ribbon. There are several ways to create a toned image in Photoshop. Here is one of the simplest methods.

TRADITIONALLY . . .

Sepia-toned photographs were originally produced by applying a pigment made from the sepia cuttlefish to the positive print. Today, images are toned using a variety of chemicals such as selenium, gold toning salt, and sulfide. Some toners are used not only for aesthetic effect but to make the print more stable. Most chemical toners are toxic, so good ventilation and gloves are mandatory.

A black-and-white photo (above) says "classic"; a sepia-toned photo (below) says "timeless." The choice is yours.

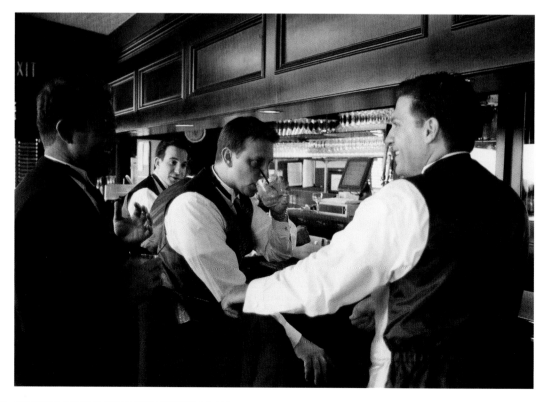

1. Open a black-and-white (Grayscale) image. (To transform a color image into a toned image, first convert it to black and white following the method detailed on page 54.)

2. Go to Image>Mode>Duotone.

3. If the Type specified in the dialog box is Monotone, choose Duotone from the pop-up menu.

4. Ink 1 should be black. Click on the color swatch (the solid box, not the one with the line across it) for Ink 2. In the Custom Colors dialog box that opens, choose a tone using the sliders on the vertical bar with arrows on each end to access the desired range, then clicking on a specific Pantone color. (Make sure you have the Preview box checked in the Duotone Options window to see the effect immediately.)

5. Alternatively, use one of Photoshop's preset duotones. To access, click the Load button in the Duotone Options dialog box. Click through the Duotone folders until you find one named Pantone Duotones. Load an orange or brown tone to create a sepia effect.

 Going back and forth between the Duotone Options dialog box and the Pantone Duotones, load one selection after another to see the different effects, then choose the one you want.

6. Choose Image>Mode>RGB Color, then go to Image>Adjustments>Hue/Saturation and play with the Saturation slider to tweak the sepia effect.

7. Save the file under a new name.

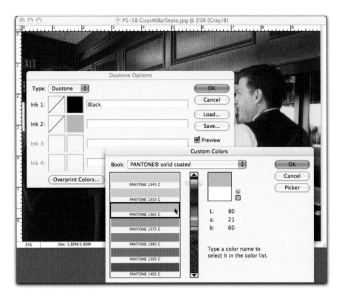

The Custom Colors dialog box allows you to choose from a wide range of tones.

Selecting a preset Photoshop duotone.

The Hue/Saturation dialog box.

The art of handcoloring photographs, which dates back to Victorian times, has been rediscovered. It's now one of the most popular trends in fine art photography, and several excellent books on the subject have recently been published. The basics are really quite simple, but mastery comes with practice, patience, and perseverance.

You can emulate the look of "painting" on a black-and-white photo using the Paintbrush tool in Photoshop, but if you're not sufficiently skilled, you'll probably prefer the technique below. It's extremely simple, and perfect if you're shooting digitally and if you want to maintain the integrity of the original colors. Using a layer mask (see the box on the next page) allows you to make changes at any time.

TRADITIONALLY . . .

Artists use cotton swabs to apply colored photo oils to a medium-contrast black-and-white image that has been printed on fiber-based paper. Color is rubbed in and built up in layers. Alternatively, colored marking pens can be used. Colored pencils are useful for controlled accuracy and small details. Both Marshall's Photo Oils and SpotPen offer handcoloring kits.

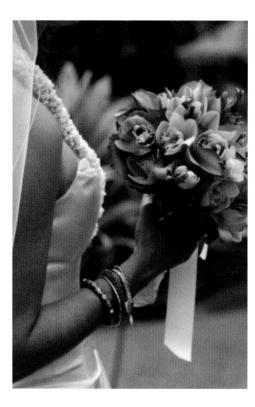

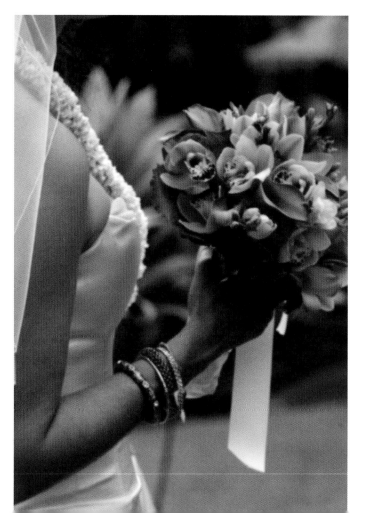

Tinting just the bouquet and bracelets draws attention to their exquisite colors and creates a subdued yet dazzling effect.

1. Start with a color image (RGB or CMYK). Go to Layer>New>Layer via Copy.

2. Choose Image>Adjustments>Desaturate.

3. Click on the Add Layer Mask icon (the rectangle with a circle in the middle) at the bottom of the Layers palette. Click on the Layer Mask thumbnail in the Layers palette to activate it.

4. In the Toolbox, make sure the foreground color is black (press X or click on the little curved arrows to the top right of the large color swatches in the Toolbox). Using a soft Brush (press B or click on the icon in the Toolbox), "paint" over the area you would like to reveal. The color from the underlying layer will appear. For a subtler effect, lower the opacity of the Brush on the options bar. Zoom in and out as necessary, and vary the size of the Brush as you work for increased maneuverability. Switch the foreground color to white to "erase" any mistakes, then back to black to continue revealing color.

5. Save the file under a new name.

Selecting the Add Layer Mask icon.

The Layer Mask thumbnail.

Switching the foreground color between white and black allows you to fix mistakes.

USING LAYER MASKS

A layer mask is essentially a black-and-white duplicate layer. You can paint on the mask in black, white, or gray. Painting in black allows the underlying picture to show through; painting in white hides the underlying picture; painting in any shade of gray affects the opacity. By adding a layer mask, you can return at any time (until and unless the image is flattened) to continue to reveal or eliminate areas of color by first single clicking on the Layer Mask thumbnail.

Step-by-Step: Cross Processing

Cross processing is a method of creating images with unexpected color shifts for an avant-garde, somewhat edgy look. Skin tones may look unnatural, while bright colors become more saturated and even bleed into each other. It's an effect frequently used in commercial applications such as advertising and fashion photography. The digital darkroom method I use for cross processing may seem complicated at first glance, but stay with it. The effect is very cool, and it's actually an easy way to experiment with some of the wonders of Photoshop.

TRADITIONALLY . . .

Slide film (E-6) is processed in chemistry meant for negative film (C-41). A favorite among professional photographers is Kodak Ektrachrome E100VS, which is sometimes "pushed" one or two stops in the processing phase to compensate for degraded exposure. Experimentation is key.

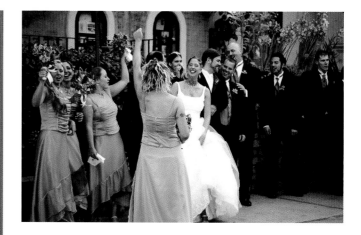

Cross processing in Photoshop brings this rather drab shot to life, adding a shade of fun that's perfectly suited to the subject matter.

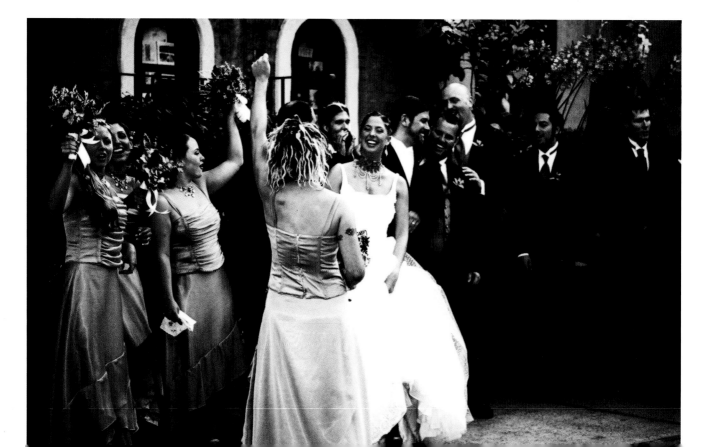

1. Start with a color image (RGB or CMYK).

2. In the Layers palette, click on the third icon from the right at the bottom of the palette (the half-black/half-white circle) to create a new adjustment layer, then choose Gradient Map.

3. In the Gradient Map window, make sure the preview box is checked, then click on the downward-facing triangle. If you click on the right-facing triangle in the new drop-down window, you'll find additional gradient palettes. I usually click on the Color Harmonies 1 or 2 palette, choosing to append rather than replace the current choices. Now, click on a gradient, any gradient, then click OK. The image will look awful, but don't worry, it's temporary.

4. In the Layers palette, with the Gradient layer highlighted, click on the drop-down menu that allows you to set the blending mode for the layer. Change the mode to Color—it's down near the bottom of the list—then adjust the layer opacity to your liking.

5. At this point, you can continue to sample gradients until you find one that perfectly suits your creative vision. Just double-click on the Layer thumbnail icon (the circle, not the mask thumbnail, on the Gradient Map layer in the Layers palette) to choose another one, and another. As you've just discovered, you can really have fun with this technique!

6. Finally, go to Layer>Flatten Image, then to Image>Adjustments>Levels where you can tweak the Input Level sliders until you're perfectly satisfied with the image.

7. Save the file under a new name. Bear in mind that once you've flattened the image, adjusted the levels, saved the file and closed it, you can no longer go into the Gradient Layer to change it. You may want to save a few different versions along the way, each with its own name, before closing the original file.

Selecting Gradient Map from the New Adjustment Layer pop-up menu.

Choosing a gradient palette from the Gradient Map drop-down window.

Setting the blending mode in the Layers palette.

A soft-focus effect can enhance the romantic feeling of a special wedding photograph, as well as blur unnecessary or unwanted details. Just don't overdo it!

TRADITIONALLY . . .

The photographer attaches a special softening filter to the camera lens to blend small wrinkles and blemishes and to impart an overall dreamy effect. Some photographers attach a clear filter smeared with a bit of petroleum jelly; others stretch a piece of sheer fabric or plastic wrap over the lens.

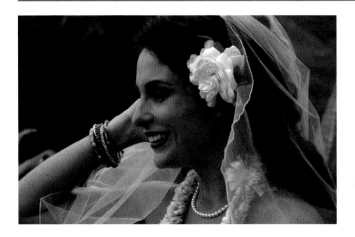

The original photo (left) is beautiful, but applying the Gaussian Blur effect (below) has added a luminance and softness befitting the subject.

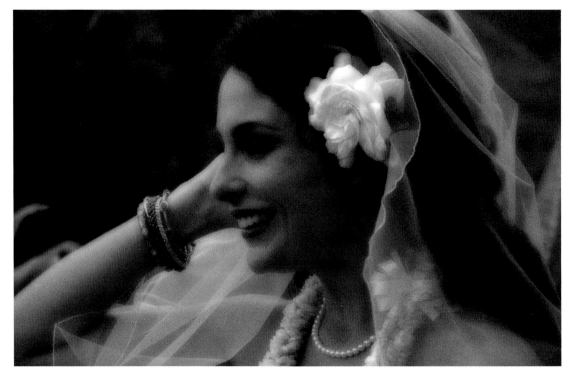

Gaussian Blur

Photoshop offers several blur options. The popular Gaussian Blur is a general-purpose filter that removes fine image detail, or noise, to produce a pure smoothing effect similar to looking through an out-of-focus lens.

1. Open a file containing an image to which you would like to apply a soft-focus effect.

2. Go to Layer>Duplicate Layer to duplicate the background layer.

3. With the Background Copy highlighted in the Layers palette, go to Filter>Blur>Gaussian Blur. In the dialog box, set the radius to somewhere between 15 and 20 pixels and click OK. Yes, it's way too blurry—quick, go to the next step!

4. In the Layers palette, again with the Background Copy highlighted, reduce the opacity to anywhere from 30 percent to 50 percent. Ahhh—perfect soft focus!

5. Save the file under a new name.

Motion Blur

Here's an effect that adds a sense of motion—and emotion—to an otherwise static shot.

1. Open a file containing an image to which you would like to apply a motion blur effect.

2. Go to Layer>Duplicate Layer to duplicate the background layer.

3. Go to Filter>Blur>Motion Blur. Make sure the Preview button is checked and move the slider to the right until you see a nice glow surrounding the subject. Click OK.

4. Click on the Add Layer Mask icon at the bottom of the Layers palette. Set the foreground color to black in the Toolbox. Using the Brush tool (B) with a soft brush, paint over the details in the areas that you want to remain sharp, such as faces, flowers, and table settings, stopping at the edges. When working on a layer mask, as described earlier (see page 59), you can alternate between a black, white, or gray brush to control the areas affected.

5. Save the file under a new name.

The Gaussian Blur dialog box.

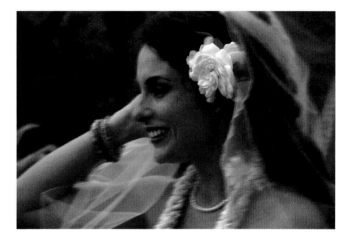

Adding a bit of motion blur to the area surrounding but excluding the bride's face creates a sense of excitement.

The Motion Blur dialog box.

Adding any type of border to a photograph is purely a matter of personal preference, but if an image is to be included in the wedding album or used on a piece of stationery, a complementary border can highlight and enhance its impact.

TRADITIONALLY . . .

Artwork is often framed with double mats so that the inside mat creates a narrow border outlining the image. Polaroid image transfers (see page 70) produce characteristic borders sought after by alternative-imaging enthusiasts. Darkroom prints sometimes intentionally include exposed negative carrier edges to produce a slightly rough black border, or labs will scan the full frame of a negative, including sprocket holes.

A thin black border adds an elegant finishing touch. It also makes an image appear sharper, particularly when the image contains light tones along its edge.

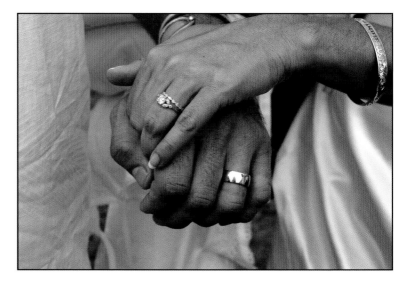

A Smooth Solid Border

1. Open a file containing an image to which you would like to apply a smooth solid border.

2. Go to Layer>Duplicate Layer and click OK to duplicate the background layer.

3. At the bottom of the Layers palette, click on the Add a Layer Style icon (the circle with the letter *F* in it at the far left) and choose Stroke from the pop-up menu.

Selecting the Add a Layer Style icon.

4. In the Layer Style dialog box, type in a size, choose the Inside or Center position, and select a color by clicking on the Color box. Click OK.

5. Save the file under a new name.

A Rough-edged Border

1. Open a file containing an image to which you would like to apply a rough-edged border.

2. Go to Layer>Duplicate Layer and click OK to duplicate the background layer, then turn off the original background layer by clicking on the eye icon next to it.

3. Go to Image>Canvas Size and increase both the height and width by about an inch.

4. Click on the Add Layer Mask icon (the rectangle with a circle in the middle) at the bottom of the Layers palette. In the Toolbox, make sure the foreground color is black.

5. Press B to activate the Brush tool, and open the Brush Preset Picker in the Options bar. Choose a rough round bristle. When working with a 4- by 6-inch image at 300 dpi, a diameter of 200 pixels is perfect. If the image is larger, make the diameter larger and vice versa.

6. Click on the top left corner of the image. Hold down the Shift key and run the stroke over to the top right corner. As you see, you have erased the pixels in a ragged straight line across the top edge of the photo. Now click on the top right corner, hold down the Shift key, and run the stroke down to the bottom right corner. Repeat on the remaining two edges to complete the rough border. If necessary, repeat this step to remove stray color pixels. And don't forget, when you're working in a layer mask, you can switch back and forth between the black and white foreground colors to control the areas being affected by the brush.

7. If you wish, go to Layer>Flatten Image, and click OK to discard hidden layers. Once you flatten the image, save it, and close it, you will no longer be able to access the layer mask.

8. Save the file under a new name.

The Layer Style dialog box.

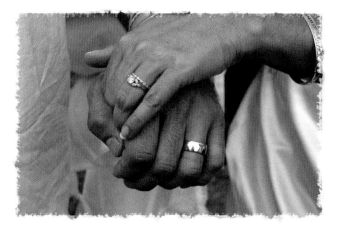

Applying a rough border is a fun way to give a photo a unique edge and actually change the mood of the image.

Choosing the type and diameter of the Brush tool.

A Sloppy Border

By experimenting with different brushes, you can create your own "sloppy" borders, a look popularized by avant-garde photographers and available through custom photo labs. Or you can borrow some of my "prefabs." Go to www.bsmithphotography.com/borders and download not only sloppy borders but some Polaroid, Hasselblad, and Ektachrome film edges. To use them:

1. Open a file containing an image to which you would like to apply a border.

2. Open the file containing the border you've chosen. Click on the edge of the border and drag it into the image file.

3. With the border layer highlighted in the Layers palette, go to Edit>Transform>Scale and drag the handles until the border is the same size as the photograph. Click Enter/Return to apply the transformation.

4. Flatten the file and save it under a new name.

Any one of these borders will add an interesting, creative edge to your photo.

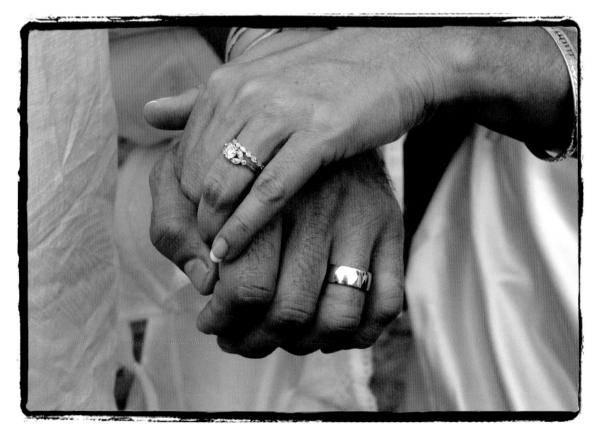

The use of a sloppy border can complement a casual image or provide contrast to an elegant shot.

Graphic artists have long designed eye-catching and complex layouts that include illustrations, photographs, overlays, screened-back effects, and painstaking typesetting, which are then printed commercially via offset lithography. The digital age has dramatically changed much of that. Anyone—even nonprofessionals—can now design dynamic layouts on a home computer, and print them as well. Here's a dazzling effect—the perfect way to add text to invitations, programs, thank-you notes, and albums.

TRADITIONALLY . . .

The strip-up artist, a skilled craftsman, uses a flat piece of film made of screen percentages in 5- and 10-percent increments. When burning the plates for the press, the required percentage is laid over the original, screening the original back as it is burned into the plate and allowing the required percentage of the image to be receptive to ink and printed.

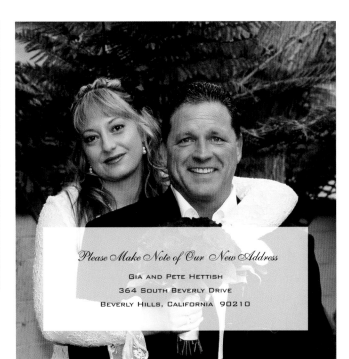

Please Make Note of Our New Address

GIA AND PETE HETTISH
364 SOUTH BEVERLY DRIVE
BEVERLY HILLS, CALIFORNIA 90210

RIGHT: Here's a clever way for the bride and groom to share one more photo from the wedding. The same concept works equally well for a thank-you note.

10.7.06

SAVE THE DATE

ANNA LUFT
&
NICHOLAS RHAMES

ARE GETTING MARRIED
IN LOS ANGELES

INVITATION TO FOLLOW

For this unique save-the-date card, I used the Polygonal Lasso tool (L) to select an irregularly shaped area as a background for the text.

1. Open an image that contains an area suitable for text.

2. Use the Rectangular Marquee tool (press M or click on the icon in the Toolbox) to select a rectangular area in which you wish to place the text.

3. Go to Layer>New>Layer via Copy. In the Layers palette, change the blending mode for the layer from Normal to Screen.

4. To lighten the selection, go to Image>Adjustments> Hue/Saturation. Check the Preview box and move the Lightness slider to the right. Go to Select>Deselect.

5. Click on the Type tool (T) to add text, or leave the area as is to accommodate a handwritten note.

6. Save the file under a new name.

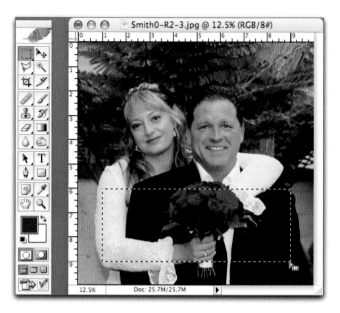

The area within the dotted lines will be screened back.

Adding text to the screened-back area.

✿ TIP

To screen back an entire image in order to add type or to give the effect of having a layer of vellum on top, simply omit step 2.

Polaroid Processes

Hopefully the digital darkroom techniques described in the preceding pages served to whet your appetite for the wondrous ways you can alter an image to create beautiful fine art effects. Here are two more very hands-on techniques sure to take your photographs to gallery level.

Many so-called alternative processes were at one time commonplace, albeit laborious, methods of producing photographs that required the use of darkroom chemicals and equipment. Using portable daylight labs and Polaroid film, the techniques presented here allow you to create artistic effects in the comfort of your own studio.

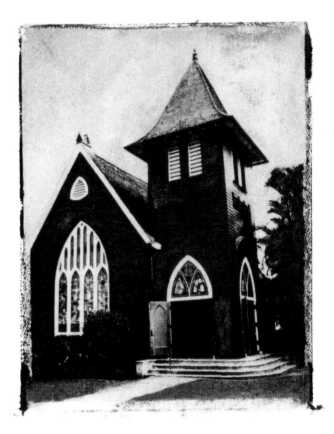

You might be surprised at the number of weddings performed at any given church, temple, or country club. Create some stock shots of the most popular wedding venues in your area. This photo was made into a Polaroid image transfer, which was than enhanced with watercolor pencils.

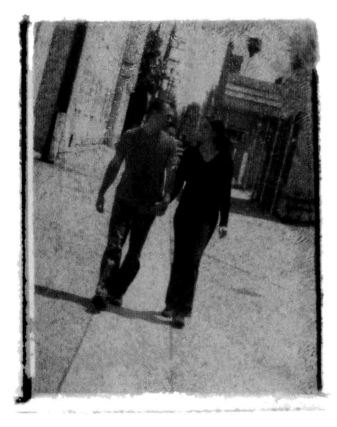

Converting this engagement photo into an image transfer created the "outsider" look this couple wanted for their save-the-date card.

Image transfer is simply the process of prematurely peeling apart a Polaroid (Type 669), thereby separating the negative from the positive, then transferring the negative onto a nonphotographic surface called a receptor sheet. This creates a subtly textured, evocative, and romantic image that is perfect for wedding stationery.

ABOVE: The Vivitar Slide Printer (top left), which copies a 35mm slide, is no longer being manufactured, but used units can often be found at camera stores and online auctions such as eBay. The Daylab II (top right) also copies a 35mm slide, and the Daylab Copy System (foreground) copies a 4- by 6-inch print. Each of these daylight labs utilizes Polaroid Type 669 film.

❧ TIP

A professional photo lab can take your negatives or positive prints and create 35mm slides, which you can then use for image transfers.

MATERIALS

Polaroid Type 669 film
One of the following:
 Vivitar Slide Printer and a 35mm slide
 Daylab Slide Printer and a 35mm slide
 Daylab Copy System and a 4- by 6-inch print
 Polaroid camera that uses Type 669 film (for a
 live shoot, in which case you don't need a slide)
 Your camera and a compatible detachable
 Polaroid adaptor back (for a live shoot)
5- by 7-inch piece of glass (borrow one from a
 picture frame)
Brayer roller
Squeegee
140-pound, 100-percent rag watercolor paper
 (hot pressed)
Distilled water
Scissors or craft knife
Hair dryer
Electric frying pan or tray
Timer (optional)
Thermometer (optional)

Image transfer supplies.

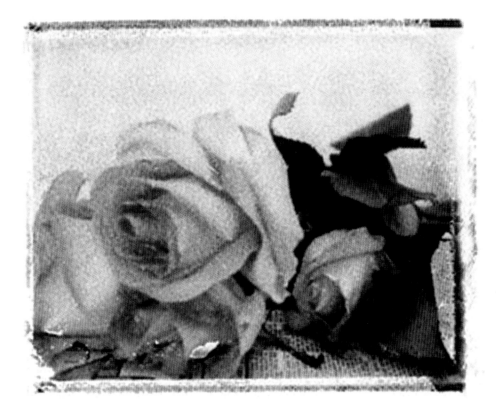

Roses are a perennial favorite when it comes to weddings—their beauty glorified in bouquets, boutonnieres, centerpieces, and other decorations. Here they are romanticized even further through the process of Polaroid image transfer.

1. Soak a 4- by 5-inch piece of watercolor paper in distilled water heated to about 100°F for one and a half to two minutes.

2. Place the wet paper on the glass and squeegee until slightly damp.

3. Process the Polaroid according to the initial instructions for the specific piece of equipment you're using. Once you've exposed the image, wait ten to fifteen seconds, then peel apart the film.

🌿 TIP

Avoid contact with the developer gel in a Polaroid Type 669 print as it contains a caustic paste. If you do get some gel on you, wash it off right away with soap and water.

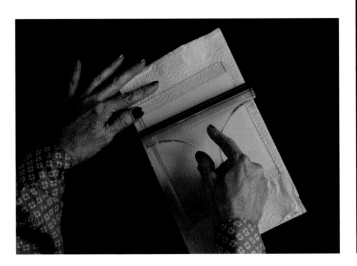

Squeegeeing the watercolor paper will remove excess water.

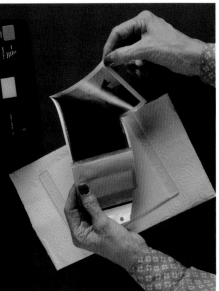

Peeling apart the film.

4. Place the negative facedown on the watercolor paper and, using the Brayer roller, roll six times in one direction with medium pressure.

5. Keep the negative warm for two minutes using a back-and-forth motion with a hair dryer or the palm of your hand.

6. Carefully lift the negative from one corner and gently peel it back, watching to ensure that the gummy emulsion isn't sticking to the print. Depending on how dense the emulsion is, for a subtler effect you might want to rinse the print, rubbing gently to remove some of the color.

7. Allow the print to dry completely.

8. Scan the image to convert it to a digital file and print as many copies as needed, or use a photocopier.

VARIATIONS

Working with Polaroid image transfers will undoubtedly inspire your inner artist. It's a wonderful opportunity to experiment with diverse art supplies and materials.

- Use artist pastels, colored pencils, or watercolors to enhance the colors of the transfer. My favorite? Watercolor pencils!
- To create a unique piece of art, transfer the image onto lightly dampened silk (use a spray bottle or mister) instead of paper, stitch it onto a piece of card stock, and frame.
- After prematurely separating the Polaroid, the negative is used to create an image transfer. But don't immediately discard that "positive"—although little dye had an opportunity to migrate and develop, the washed-out result has a faded beauty of its own.

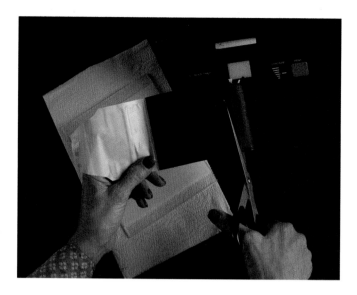

Cutting the end of the film a few seconds before peeling creates a neater edge.

Transferring the print to the watercolor paper.

Peeling back the negative reveals the transferred image.

An emulsion lift is created with the same Type 669 film as an image transfer, yet it produces an entirely different look. This process entails soaking a fully developed print in hot water until the image begins to lift from its backing, then sliding it onto a new receptor sheet, thereby creating an unusual and intriguing design.

Basic supplies for making Polaroid emulsion lifts.

The bride's veil blowing in the breeze and the swirling water made this shot a perfect candidate for an emulsion lift.

MATERIALS ··

Polaroid Type 669 film
One of the following:
 Vivitar Slide Printer and a 35mm slide
 Daylab Slide Printer and a 35mm slide
 Daylab Copy System and a 4- by 6-inch print
 Polaroid camera that uses Type 669 film (for a
 live shoot, in which case you don't need a slide)
 Your camera and a compatible detachable
 Polaroid adaptor back (for a live shoot)
Distilled water
Electric frying pan
Tray containing room temperature distilled water
Tongs
Adhesive vinyl contact paper (Contac)
Brayer roller
Hair dryer (optional)
Scissors or a craft knife
140-pound, 100-percent rag watercolor paper
 (hot pressed)
Timer (optional)

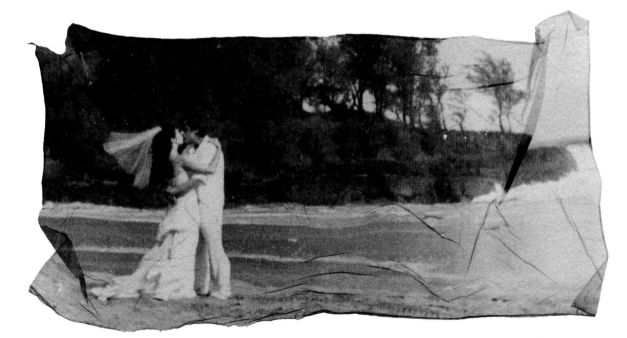

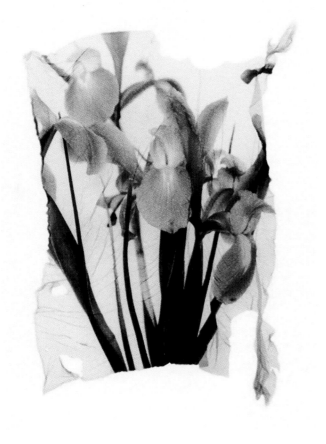

The flowing look of an emulsion lift makes it a great technique for images containing flowers, water, or fabric. This interpretation of irises is appropriate for wedding or shower invitations, thank-you notes, guest books, and albums.

1. Process the Polaroid according to the initial instructions for the specific piece of equipment you're using. Develop the film for sixty seconds, then separate the positive from the negative in the usual manner. Allow the print to dry completely, or force dry with a hair dryer.

2. Cut a piece of vinyl contact paper slightly larger than the print. Peel and adhere it to the back of the print. (This will prevent the backing from dissolving when it is immersed in the hot water in step 4.)

3. If you wish, you can trim off the white borders surrounding the image, or cut the image into a different shape or size.

4. Heat the distilled water in the electric frying pan to 160°F and immerse the print face up, keeping the entire print underwater for three to four minutes, or until the emulsion begins to bubble.

TRANSFERRING IMAGES TO OBJECTS

Once separated from its backing, the malleable emulsion can be transferred to almost any surface imaginable, even decorative objects such as bud vases, votives, tiles, or stemware—just the thing for favors and thank-you gifts. If the object is too large to immerse in the water, use an acetate sheet as a temporary receptor, then slide and press the emulsion onto the new receptor surface. Just remember to first flip the emulsion during the cold-water stage (step 5, opposite page) or it will be reversed when you transfer it to another object. Emulsion transfers are fragile and susceptible to flaking or chipping when applied to three-dimensional objects; therefore, once dry, protect the image with a clear protective spray or varnish and avoid washing.

Immersing the print in heated water loosens the emulsion.

5. Use tongs to transfer the print from the hot water to the room temperature water, being careful not to tear the emulsion.

6. With your fingers, nudge the emulsion away from the edges of the print toward the center until it separates from the backing. Discard the backing.

7. If you feel any gel-like substance clinging to the emulsion, gently rub it off.

8. Slide a piece of watercolor paper into the water under the floating emulsion, then lift and dip the assembly to rearrange it as desired, and to remove any unwanted wrinkles. The emulsion will stretch or even tear the longer it remains in the water; this may or may not be desirable. Areas containing light hues stretch the easiest.

9. On a flat surface, you can manipulate the image further by tearing it, wrinkling it, or stretching it.

10. When you're satisfied with the arrangement, go over it very lightly with a wet Brayer roller to remove any air bubbles and to flatten, then allow it to air dry.

11. Scan the image to convert it to a digital file and print as many copies as needed, or use a photocopier.

Separating the emulsion from the backing.

VARIATIONS

Be careful not to overwork your emulsion lifts—it's easy to do. As is often the case, less is more, and the wrinkles and/or tears usually add adequate visual interest. However, if you do want to take your image a step further, you can add multiple lifts to the same piece of paper to create a photomontage or try attaching organic or found materials to the final print.

Arranging the emulsion on the watercolor paper.

Infrared Photography

Shooting with infrared film can produce dreamy, atmospheric imagery. Many wedding photographers now include infrared shots in their repertoire.

The seemingly esoteric nature of infrared film—it captures light rays that are invisible to the human eye—prevents many amateur photographers from experimenting with it, but it's not necessary to understand the whys and wherefores of infrared film in order to use it.

There are certainly several dos and don'ts governing the use of infrared film, but it's actually quite simple to get spectacular results. The most dramatic shots usually include foliage and/or sky. Leaves and clouds often produce a haloed effect; water and sky may turn almost black. People's eyes usually turn dark, and their skin pales. Colors behave differently, as do surfaces. Experimentation is key; but at the same time, unexpected results add to the excitement inherent in this process.

As with all film, it's best to purchase infrared film that has been kept in a refrigerator, and keep it refrigerated until you use it. Shoot and process the film as soon as possible. Infrared film that has been left in the camera may fog, resulting in muddy or flat images.

Sunlight will definitely fog the film, so you must open the film container, load, and unload the film within a black changing bag, available at most camera stores. You don't need to purchase the most elaborate one in stock; my inexpensive bag has served me perfectly well. It's really two zippered bags nestled within each other, with sleeves and elasticized cuffs for inserting your arms.

Loading and unloading by sense of touch takes some getting used to, so you might want to practice with an expendable roll of film. Always save the black container and lid to protect your exposed roll. Once recapped, put tape over the top of the container

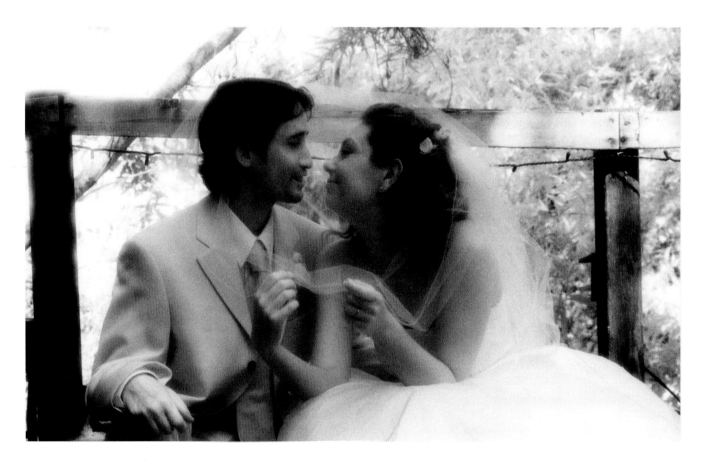

Using infrared film adds a dreamy quality to this romantic shot.

to remind yourself, *and the lab*, that it can be opened only in complete darkness.

On your first time out, choose a bright sunny day, and follow these tips:

- Load Kodak HIE (High-speed Infrared) film in total darkness.
- Manually set the film speed (ASA/ISO) on your camera to 200.
- Affix a #25 (red) or #29 (deep red) filter to your lens.
- Set your shutter speed to 1/125 of a second.
- Select a small aperture (*f*11 is a good place to start) for a fairly extended depth of field.
- If possible, use a lens with a fixed focal length and that allows manual focusing. It's almost impossible to judge the focusing point when using infrared film, so if your lens has an infrared focusing mark (most zoom lenses do not), use it as directed in your camera manual. If it doesn't, focus on the middle distance.
- Expose the first frame, then bracket.
- Shoot the entire roll in this manner.
- Unload the film in total darkness.

When you take the film in to be developed, advise the lab that the film is infrared. They may have their own routine for infrared processing; if not, ask them to process it as they would T-Max 100.

Once you've got the hang of shooting infrared film, expand your experimentation. Set a faster or slower film speed to increase or decrease the grain. Open up your aperture for a shallower depth of field. Use a lighter-colored filter, say a #23, for a subtler effect. Shoot indoors, using a tripod if necessary.

Most infrared prints lend themselves beautifully to further creative exploration with coloring or toning, either by hand or digitally. The foliage in this shot was colored in Photoshop by using a large spatter brush at 15-percent opacity, varying the shades of green, and daubing to produce a mottled effect.

❧ TIP

Many professional photographers routinely *bracket* to ensure a properly exposed photograph. To bracket, take two additional exposures, each a half stop on either side of the recommended exposure.

Chapter 5

PAPERCRAFTING

Papercrafting and book arts are enjoying a Renaissance, and today's brides are looking for unique wedding stationery ensembles, guest books, and albums that speak to this fact. In this chapter, basic materials and techniques used throughout the next few chapters are introduced. Handmade and digital papers unite in a marriage of old and new technology. Combining the perfect photograph with complementary papers, type, and embellishments, even the simple act of folding the paper—it all adds up to a kind of sensory epiphany, a quiet wow. You may be surprised to discover just how satisfying and rewarding it is to create custom stationery.

Types of Paper

The paper you select as the foundation for each piece of stationery plays an important role in its overall design—it can actually make or break the effect you wish to achieve.

You'll find a wide and wonderful selection of diverse papers in art supply, office supply, scrapbooking, and stationery stores, as well as online. Each paper's texture, weight, and thickness will determine its use. I often use a heavy paper or card stock for the cover of an invitation, then line it with a lightweight paper on which the text is printed. Unless you're adhering your printed layout to a decorative backing or using it as a liner or insert, choose printing paper with strong character. A toothy fine art stock with a weight commensurate with a significant occasion will send a clear message: classic, elegant, crafty, or contemporary. Art supply stores sell decorative and watercolor papers in large sheets—usually around 22 by 30 inches—that can be cut down to size as needed. Store paper in a dry place and keep it flat, if possible, or loosely rolled.

Paper is a versatile and exciting medium for creative self-expression. You can fold it, cut it, print on it, and decorate it. But each type of paper has a distinctive "personality," you might even say a will of its own. For instance, most paper has a *grain*, the direction in which the fibers lie. Paper resists being torn or folded against its grain, so find the grain and plan your layout accordingly. That being said, if you happen to have a piece of stock of a certain size that necessitates folding or cutting against the grain, go ahead and inflict your will upon it. The world won't come to an end; the piece simply may not fold quite as neatly or lie quite as flat as it would otherwise.

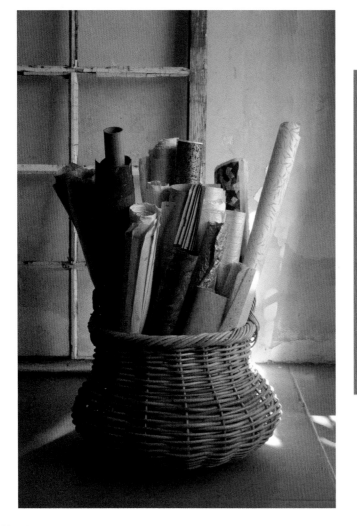

GOING WITH THE GRAIN

These simple exercises illustrate the concept of grain: Take a sheet of newspaper and tear it in different directions. Notice how easily it tears in one direction—along the grain—but not in the other. With heavier paper or card stock (stiff, thick, or sturdy paper or cardboard), hold a sheet by opposite edges and gently move them toward each other, taking note of the degree of resistance. Now rotate the sheet a quarter turn and do the same. The card has more "give" when bent along the grain.

Oh, my kingdom for a vintage flat file! This isn't the best way to store paper, but there you have it.

Printable Papers

Papers created specifically for your printer, be it laser, inkjet, or something else, will yield the best results as far as clarity and tone. So unless your *intention* is a less-than-perfect reproduction of your photograph, it's best to print images on paper that has been coated for that purpose. Check the specifications for each to see if they are compatible with the printer you will be using.

Your printer can likely accept a wide variety of paper thicknesses. Most printers have an adjustable lever to accommodate card stock and envelopes.

Don't try to print on paper that has loose components (such as fibers or flower petals) that could catch or fall off into the printer and cause serious damage. Textured paper tends to absorb more ink, which can then bleed, making your image or text appear soft and even difficult to read.

Available at computer and office supply stores and through the Internet, the following papers have special coatings—usually on one side only—that make them ideally suited for imprinting both text and imagery.

These high-quality photo papers produce beautiful prints.

EPSON

As I use an Epson inkjet printer, I frequently use Epson products, including Photo Quality Inkjet Paper, Matte Paper, Premium Glossy Photo Paper, and Premium Luster Photo Paper.

ARCHES INFINITY

Arches Infinity Museum Quality Digital Art and Photo Inkjet Paper produces beautiful results. My personal favorite, Arches Infinity Smooth Natural White, is a high-quality fine art paper with a creamy, warm color and a velvety texture, offered in two weights. It is also available in a pebbly textured surface in two weights.

SOMERSET PHOTO ENHANCED VELVET

Another excellent fine art paper, mold-made in England. Be aware that once you've removed the paper from the package, it's almost impossible to differentiate one side from the other, yet it's critical to print on the correct side.

HAWK MOUNTAIN PAPERS

A friendly, family-owned business, Hawk Mountain has American-made digital papers for just about every purpose, and at very reasonable prices.

HAHNEMÜHLE

Somewhere within its three Lumijet collections—Portfolio Series, Preservation Series, and Inkjet Fine Art Papers—you'll find the perfect medium for just about any project, including dual-sided, parchment, woven, and canvas papers.

VELLUM

The recent availability of what is commonly called vellum has had a dynamic visual impact on greeting cards, scrapbook pages, and even commercial book covers. Its translucent quality adds a dimension of interest, whether printed or as a simple overlay. Originally available in only lightweight and heavyweight clear vellum, today there's a rainbow of colors to choose from, as well as patterned, embossed, and even metallic finishes. Most vellum is better suited to laser printers than inkjet. Experiment, and always let each sheet dry undisturbed.

Nonprintable Papers

When it comes to decorative paper, avoid school-grade construction paper like the plague, and be careful with shiny wrapping paper: Both will almost certainly render your design childish, tacky, or both. Commonly found in art supply and stationery stores, the papers described below are not coated for printing and are best used as foundations, covers, album pages, or as decorative elements.

WATERCOLOR PAPER

Arches Aquarelle, my customary choice, is made from 100-percent rag (cotton), has a neutral pH value that make it acid free, has deckled edges, and is watermarked. It's available in three weights—90-pound, 140-pound, and 300-pound—and in three textures—hot pressed (smooth), cold pressed (medium texture), and rough (the most texture).

SPECIALTY PAPERS

There are many beautiful handmade, mold-made, or machine-made specialty papers available. From far and near—Japan, Egypt, India, Thailand, Taiwan, the Philippines, and the United States—these unusual and often exquisite papers can be expensive—I've paid up to sixteen dollars for a single sheet of paper!—but add a decidedly handcrafted quality to cards and albums. You'll find myriad colors and textures to choose from. These papers often do not have a grain.

CANSON MI-TEINTES

This easy-to-find paper has a textured surface and is available in a rainbow of solid colors.

THEMED AND PATTERNED PAPERS

Explore the scrapbooking section of craft stores for other types of specialty papers you can incorporate into your stationery.

Handmade papers from around the world to complement any wedding theme or color scheme.

Board

Art supply stores often carry a bewildering variety of 32- by 40-inch boards used in paper and book arts, including binder's board, bristol board, chipboard, foamboard, illustration board, mat board, millboard, museum board, and photo board. The two most commonly used are mat board and museum board. Mat board may be only partially archival; museum board is 100-percent cotton rag, archival through and through. Both are available in varying thicknesses and a wide assortment of colors. When creating a beveled mat, you may want to use a two- or four-ply board that is one color throughout as opposed to a mat that is, say, white on the outside but gray at its core.

ARCHIVAL CONSIDERATIONS

In making keepsake stationery, we want to create mementos to be cherished for years to come. With that in mind, whenever possible, use products—especially paper and adhesives—bearing the words "acid free" or "archival." Acid-free products have a pH value of 7.0 or higher and resist deterioration. Many of the products listed here are such, but some are not. I have a photo-based card that I made over thirty years ago with absolutely no archival considerations, and it looks almost exactly the same today as it did then.

The beautiful deckled edge of watercolor paper is worthy of preserving whenever possible.

The Toolbox

Your tools need not look brand new for long—mark them up, adapt them to your personal needs, and make them part of your art. Wrap a rubber band around the shaft of your craft knife to provide a non-slip grip—or purchase one of those spongy little sleeves made precisely for that purpose. Go ahead and make notes on your cutting mat, mark corner anchor points, or adhere tape to help align cards more quickly. Your tools and supplies will come to feel like old friends—comfortable and familiar.

Cutting Tools

Using the correct tool for the job at hand will make your life oh-so-much easier.

- Paper cutter or trimmer—for straight cuts
- Craft or utility knife with replaceable blade—for straight cuts and windows
- Die cutter—a piece of rather heavy equipment for one-step cutting of windows and shapes; great for repetitive work and especially if you plan to devote a lot of time and energy to papercrafting
- Sharp scissors—a small pair for detail work such as trimming photos and cutting out other paper designs and shapes
- Decorative scissors—for creating special edges such as ripples, zigzags, and scallops
- Mat cutter—for creating a beveled window in a thick mat board
- Hole punch—for making holes for eyelets or for threading ribbon or fiber
- Circle cutter—to cut mat windows and shapes

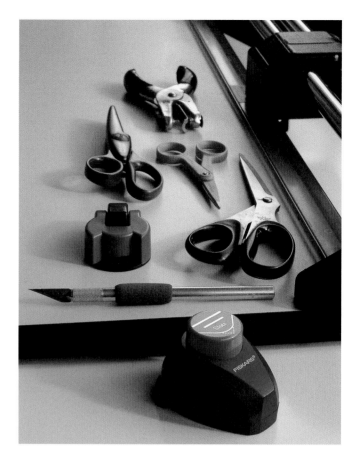

Cutting tools include a paper punch, craft knife, corner rounder, scissors, decorative scissors, hole punch, and paper cutter.

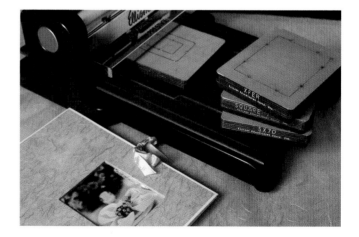

An Ellison die cutter is worth its considerable weight—47 pounds—in gold for cutting windows in book and album covers. Custom dies can be made to your specifications.

Adhesives

There are several types of adhesives available for different aspects of papercrafting, and several brands within each category. You'll come to prefer one over another as time goes by. My workstation contains the following:

GLUE

- Acid-free glue sticks—for adhering small, irregular-shaped surfaces, and for mounting small background sheets to pages
- Lineco Neutral pH Adhesive—for papercrafting, collage, and bookbinding
- Yes! Paste—acid free and won't curl or wrinkle paper, no matter how lightweight it is; can be thinned with warm distilled water, is transparent when applied, and dries quickly

TAPE

- Double-sided tape—Scotch/3M makes an acid-free photo and document tape that is neater and easier to use than glue
- Drafting or removable tape—can be used to hold items in place temporarily or while positioning them Linen hinging tape—for attaching a mat to a backing board; Lineco manufactures a self-adhesive archival product that makes the hinging process quick and easy

PHOTO CORNERS OR CORNER MOUNTS

These hold photos securely but also allow easy removal, if needed. The corners are affixed to the page and the photo is slipped in. They are available in a variety of colors and designs. The self-adhesive corners are easier to use than the type that must be moistened first. Lineco makes a clear self-adhesive archival product for use when the corners will be hidden.

PHOTO SPLITS OR MOUNTING TABS

These double-sided self-adhesive stickers are used for mounting photos or other papers.

SPRAY ADHESIVE

This product produces a fine, sticky mist that is efficient for adhering large surfaces. Some types allow repositioning, others do not.

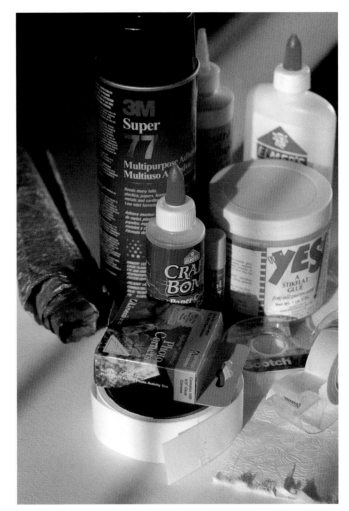

Sticky stuff, including archival linen hinging tape, photo corners, temporary and double-sided tape, and several kinds of glue.

❈ TIP

To retain spray (and/or to protect the surrounding area from overspray), make a spray booth from a large cardboard box. Before each use, lay down a clean liner of newspaper, pages from an old phone book, or recycled paper to prevent items—especially photographs—from sticking or picking up residue from prior applications. Always spray outdoors or in a well-ventilated area to avoid inhaling harmful vapors.

Miscellaneous Tools

These additional items will make your job easier and help give your work a professional, polished finish:

- Ruler—metal with cork bottoms are best; the metal is durable and doesn't get nicked by craft knives, and the cork bottom prevents slippage
- "Self-healing" cutting mats—protect work surfaces and extend the life of craft knife blades; they also have grids that make measuring a breeze
- Bone folder—a flat tool used to create clean, crisp folds, to score, and to burnish
- Pencil and eraser—for marking and erasing layouts
- Marvy/Uchida Liquid Gold opaque paint marker—use the broad line tip for gilding the edges of card stock; for lettering, use the extra fine point
- Light box—helpful for lining up design elements and for lettering
- Punch set and rubber mallet—for making spine holes in handmade books

More Fun Tools

Although not essential tools, here are some handy gadgets that are available at most hobby and scrapbook shops:

- Paper punches—to add small design motifs such as a fleur-de-lis; corner rounders are also available
- Paper crimper—gives paper (and other materials such as foil) a "corrugated" or rippled texture
- Calligraphy pens and markers—for hand lettering
- Glue gun—for adhering millinery and other three-dimensional objects
- Eyelets and eyelet setter, brads, metal alphabets—fun stuff!

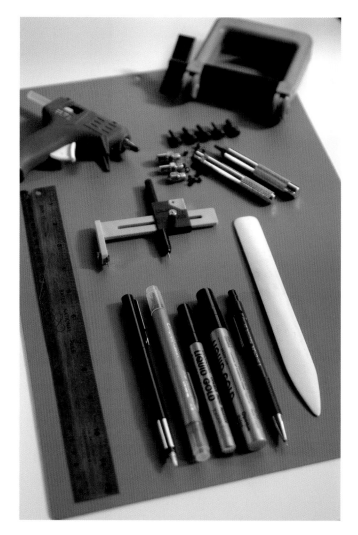

Some useful supplies to have on hand include a self-healing cutting mat, bone folder, pencil with eraser, metallic markers, calligraphy pens, ruler, circle cutter, eyelet setter, punch set, paper crimper, and glue gun.

HANDMADE, NOT HOMEMADE

As a photographer, you no doubt have an eye for detail. For example, you know that a skewed horizon or an unidentifiable blob can ruin an otherwise strong image. It's imperative that you bring that same discerning eye to papercrafting. Even though a piece's charm may lie in the fact that it was assembled by hand, for a professional look all edges and folds must be neat, straight, and smooth, and there should be no uneven scissor cuts or telltale smears of glue or paste.

Basic Techniques

Now we come to the *craft* of keepsake photography. As with any true craft, it's a matter of affinity for technique, tactile awareness, and skilled performance. These are simple techniques—mostly folding and cutting—but to do them well requires practice. And do them well we must, because we're creating keepsakes of one of life's most special occasions— the wedding. Did you know that much of the appeal of origami is derived from the simple act of folding the paper? Welcome to the joy of papercrafting!

Folding

For a crisp, clean fold when using heavy paper or card stock, always score the paper first: Use a ruler or straightedge in conjunction with the grid on a self-healing cutting mat to determine where the fold belongs. Place the ruler or straightedge in position and run the pointed end of a bone folder along the edge, creating an indentation or groove in the paper. For especially thick card stock, use a craft knife instead, being careful to penetrate the surface only slightly.

Fold the paper (with the groove on the outside), then burnish with the long edge of the bone folder to sharpen the crease. To prevent the paper from becoming shiny, lay a piece of scrap paper over the fold before burnishing.

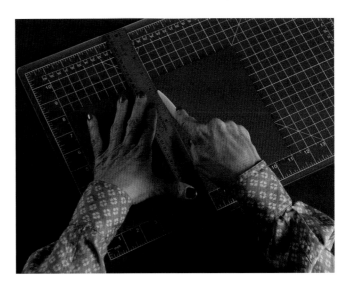

Scoring the paper before folding.

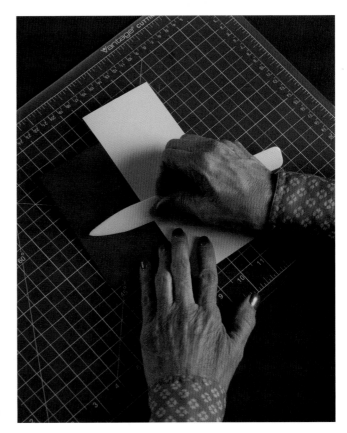

Burnishing the folded paper.

✤ TIP

Self-healing cutting mats are available in a range of sizes. Use a letter-size mat when measuring, folding, or cutting individual stationery pieces, such as cards and announcements, and a medium-size mat (approximately 12 by 18 inches) for larger items. If you have the space, an even larger mat (anything over 24 inches) is helpful for measuring and cutting down oversize sheets and for laying out album covers.

Cutting

Using a well-designed paper cutter or trimmer is the easiest and fastest way to cut straight edges. Self-sharpening roller, or rotary, cutters are generally more accurate than the handle type and are capable of trimming to a hair's width. Most cutters have a built-in ruler to aid in measuring.

To cut out windows or shapes, use a craft knife with a fresh blade, a steel ruler (the blade can catch in a soft wood or plastic ruler), and a self-healing cutting mat. There's no need to mark up your papers: For neatness and accuracy, use the grid on the mat to measure and align paper while cutting. Hold the knife just as you would a pen, and cut in a firm downward motion. Craft knife blades are very sharp, so exercise caution when using, and store in a safe place.

Faux Deckling

A deckle is the natural rough edge on a mold-made or handmade sheet of paper before it's been trimmed. Almost any paper that can be cut can also be torn for an interesting deckled look. Tear the paper randomly, or tear against the edge of a straight or decorative ruler for more control.

Gilding

To gild the edges of watercolor or fine art digital paper, prime a broad-line Liquid Gold marker so that the tip is infused with paint. Place a ruler on the paper about $1/16$ inch away from the edge and run the marker toward you along the margin in a smooth stroke. Repeat if necessary. For more delicate gilding, hold the sheet up with one hand and with the other run the tip or the side of the marker along the sharp outside edge of the paper.

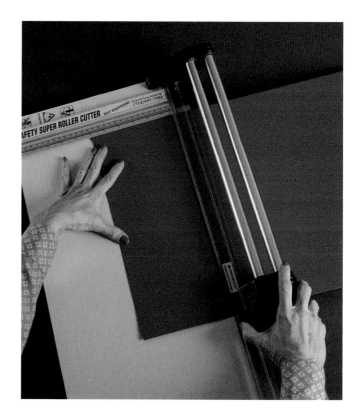

A rotary cutter makes it simple to cut clean, straight edges.

Gilding adds a touch of elegance and luxury to a wedding invitation.

Hand Lettering

You probably won't want to hand letter a large number of invitations, but you can certainly create a "camera-ready" master, scan it, import it into Photoshop, and output it that way.

Always practice lettering on a separate piece of paper before attempting to write directly on your card or album page. When writing directly on lightweight paper, vellum, or transparency film, tape a piece of lined paper onto a light box. Turn on the light box, place a blank sheet over it, and write to your heart's content, knowing that your lettering will be perfectly straight. You can also perform this same technique using a window during daylight hours.

Letterpress Printing

Letterpress printing, a technique in which a raised surface is inked and pressed into a sheet of paper, is labor intensive and requires not only a letterpress but a high degree of skill and craftsmanship. Letterpress began in Europe in the fourteenth century and eventually gave way to faster and cheaper printing methods, but it has been rediscovered and is now considered an art valued for its unique beauty and tactile quality. It has become one of the biggest trends in wedding invitations. I mention it here because it's a possibility you may want to explore in printing the text for your invitations or announcements. Instruction is available through workshops and art institutes.

THE NATURE OF REPETITION

Sometimes the repetitive nature of making lots of invitations may seem tedious, but instead, think of it as meditation, lulling you into a quiet, receptive state. Repetition can provide a fertile mental ground where ideas form effortlessly. I often have to put my work aside for a moment while I run to make notes about a new idea that has bubbled to the surface.

When called upon to make hundreds of the same invitation or announcement, it helps to break each segment of the job up into groups of ten or twenty-five, taking a breather between "sets" to walk around, grab a bite to eat, make a phone call. Just disconnect for a few minutes.

There's a natural balance between photography—a social activity—and the creation and assembly of custom stationery—a quiet, solitary activity. The interplay satisfies diverse needs and pleasures.

Adopting an assembly-line approach to putting together invitations saves time and allows you to concentrate on one task at a time.

RE MARRIED

ber 22

AND FIVE

N THE AFTERNOON

MP NASH

AINIHA, KAUAI

ALOHA ATTIRE

Amber Marlowe

to

Christopher Wright

ARD TO CELEBRATING WITH YOU!

RESPOND BY SEPTEMBER 1ST

REGRETS

PTS

Response

Please reply by the first of Augus

☐ accept with ples

5

MS. CELEST GARNET

Mr. and Mrs.

request the honor

at the marriag

Ren

William

Saturday, the

Two

at Three

Wams

Los Angeles

Chapter 6

CREATING DIGITAL LAYOUTS

You're about to enter an exciting realm that, amazingly, few people seem to know about. As a photographer, chances are you use Photoshop to edit your images, and that's about it. Well, with each new version of Photoshop, improvements were made to its desktop publishing features, and it's now relatively easy to use it to design professional-looking graphic layouts. This is the concept at the heart of this book, and you'll use it to create gorgeous keepsake wedding stationery, guest books, and albums. This chapter describes layout basics to serve as a springboard for your own ideas.

Sample Text Layouts

The examples below illustrate some traditional as well as innovative layouts for wedding invitations. You can incorporate your photographs into the design, add them as a background layer, or attach them to a cover, band, or tag.

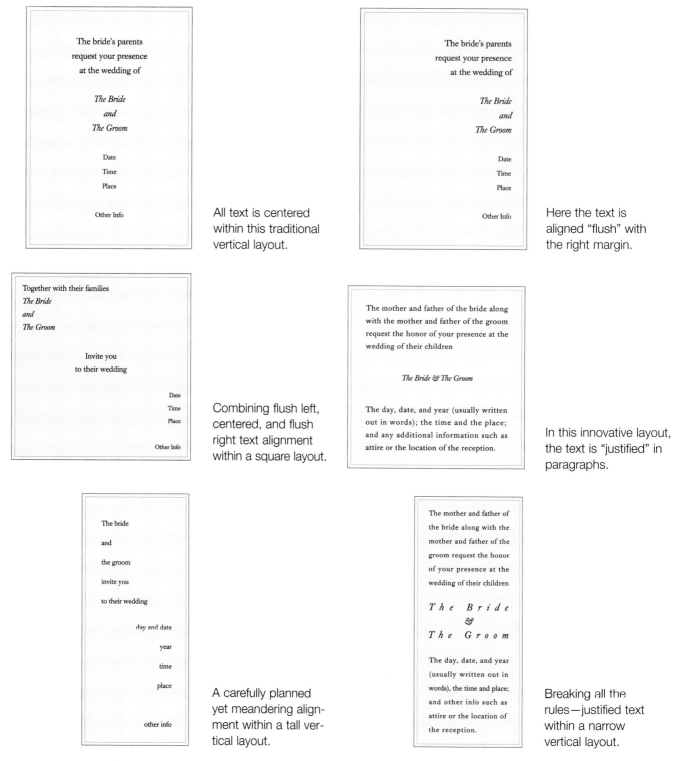

The bride's parents
request your presence
at the wedding of

The Bride
and
The Groom

Date
Time
Place

Other Info

All text is centered within this traditional vertical layout.

The bride's parents
request your presence
at the wedding of

The Bride
and
The Groom

Date
Time
Place

Other Info

Here the text is aligned "flush" with the right margin.

Together with their families
The Bride
and
The Groom

Invite you
to their wedding

Date
Time
Place

Other Info

Combining flush left, centered, and flush right text alignment within a square layout.

The mother and father of the bride along with the mother and father of the groom request the honor of your presence at the wedding of their children

The Bride & The Groom

The day, date, and year (usually written out in words); the time and the place; and any additional information such as attire or the location of the reception.

In this innovative layout, the text is "justified" in paragraphs.

The bride

and

the groom

invite you

to their wedding

day and date

year

time

place

other info

A carefully planned yet meandering alignment within a tall vertical layout.

The mother and father of the bride along with the mother and father of the groom request the honor of your presence at the wedding of their children

The Bride
&
The Groom

The day, date, and year (usually written out in words), the time and place; and other info such as attire or the location of the reception.

Breaking all the rules—justified text within a narrow vertical layout.

Creating Layouts with a Digital-Imaging Program

Most professional designers create their layouts in programs like QuarkXpress and Adobe inDesign. These are wonderful and complex programs capable of rendering exquisitely precise layouts, which is a must when the files will be output through a commercial printing press. For our purposes, Photoshop is the perfect program. If you haven't used the layers feature in Photoshop before, now is the time to start. Think of layers as clear sheets. If you printed in different areas of each sheet, then stacked the sheets together, you'd see one layout.

❧ TIP

Vary the size of the text within a layout to create visual interest. For instance, when designing wedding invitations, enlarge the names of the bride and groom, or just their initials, to add contrast and draw attention to them. Invitations look best with a lot of "white space" within and surrounding the text. Airiness adds elegance and prevents the piece from looking too busy.

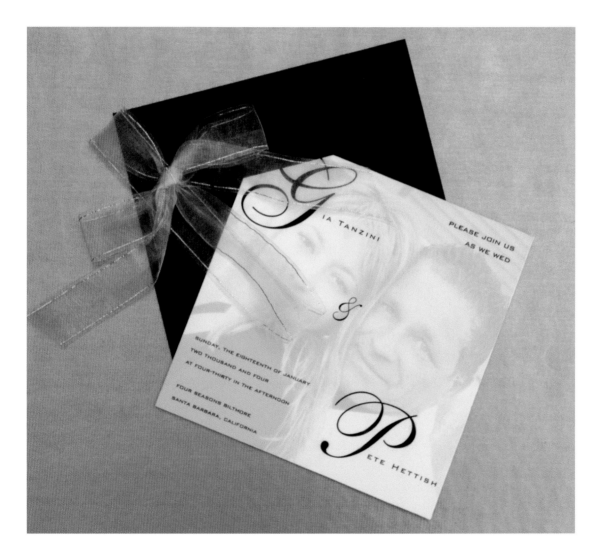

This deluxe invitation was easier to lay out than it looks. The opacity on the image layer was lowered, then layers of text were added. By putting text blocks and elements on separate layers, they can be edited and moved independently. The final image was printed on 8 ½- by 11-inch photo paper, trimmed to a 6 ¼-inch square, then mounted on 90-pound, hot-pressed watercolor paper. *(Fonts: Shelley Allegro and Bank Gothic Light)*

Basic Steps

To create a layout containing an image and text in Adobe Photoshop, it's as simple as 1, 2, 3, 4, 5, and 6! Follow these simple steps:

1. Choose File>New and select a size or create a custom size that conforms to the *intended* or finished size of your paper or card stock. Also select a resolution (300 dpi) and color mode (usually RGB).

2. Go to File>Page Setup and select or create a setup that conforms to the *actual* size of your paper or card stock. It's often easiest to use letter-size paper and then trim it after printing. Designate the proper printing orientation.

3. If an image is to be included as part of the printed layout, open an image file. If you have added layers in Photoshop, be sure to flatten the image. If the image needs to be smaller to fit into the new layout, go to Image>Size and resize the image to approximately the size you need. Be sure the resolution is the same as that of the previously opened new file (300 dpi). Choose Select>All, then Edit>Copy. Close the image file *without saving it.*

4. Return to the new file by clicking on the window and go to Edit>Paste. The image will appear in the middle of the layout; use the Move tool (V) to reposition it as required. Note that in the Layers palette, the image is on its own layer; you can edit it, move it, or resize it at any time by first clicking on that layer.

5. Select the Type tool (T) and type the text. To format text, drag across it to highlight it, then choose a font family, style, size, and color. (See "Managing Text" on the next page for more information.) As above, note that in the Layers palette, the text is on its own layer; you can edit it, move it, or resize it at any time by first clicking on that layer.

6. Save the file.

❧ TIP

To activate a layer, click on the layer in the Layers palette. If you select the Move tool (V), then turn on Auto Select Layer in the Options bar, you can activate a layer simply by clicking with the Move tool on a pixel on that layer.

GANGING

To avoid wasting paper, whenever you can, print more than one layout on a sheet. In the printing industry, this is called *ganging*. Use guides (View>New Guide) to partition the sheet. The guides won't show when printed.

Here a flattened reply card layout was copied and pasted four times on one sheet of letter-size paper for printing, saving both time and materials.

Resizing an Image in Photoshop

Here are two ways of resizing an image to work with your layout.

METHOD 1
Use this method when you know the exact dimensions you want. Go to Image>Image Size. Make sure Scale Styles, Constrain Proportions, and Resample Image (Bicubic) are checked. Enter a height or width to set the document size and click OK.

METHOD 2
If the image is in its own file with no layers: Go to Select>All, then Edit>Free Transform.

If the image exists within a layered file: With that image's layer highlighted, use the Rectangular Marquee tool to select the image, then go to Edit>Free Transform.

Either way, then resize the photo by either entering percentages in the width and height boxes in the Options bar (e.g., 50 percent in each box to make it half as large), or by dragging a handle. To scale proportionately, hold down the Shift key while dragging.

Press Enter/Return to apply the transformation.

Managing Text

It's a good idea to type groups of related information (e.g., names, date and time, address and city) on separate layers so that you have the ability to edit or move them independently. To do that, once you've finished typing the first item or grouping, click on the Move tool, click on the Type tool again, then click on the open window and a new layer will be created. Follow that process for each additional component. To edit text—for example, to change the font or point size—make sure the appropriate layer is highlighted in the Layers palette, and with the Type tool activated, drag across the text to select it, then make the appropriate changes. Use the Type options bar as well as the Character palette—Character should be checked under the Window menu, or click on the icon located near the right end of the Type Options bar—to finesse the text (e.g., alignment, color, and spacing).

Making Digital Templates

Create a new folder called "Templates," and each time you generate a new design layout, save a layered version in that folder with an apt designation (e.g., 5x5 Template, Folio Template, etc.). Then, to begin a new project utilizing an existing layout, open the appropriate template. Immediately rename it and save it in a folder for that particular project (e.g., Jones Invitation), thereby maintaining the original template with its original name intact. Make the pertinent changes (e.g., modifying the text, swapping images, etc.) to the new file, and then save that file in both layered and flattened formats.

❀ TIP

As with any digital endeavor, it's always a good idea to periodically save your work as you progress.

USING FONTS

Okay, I'm a font freak, a fontophile, a type nut. The ability to download myriad typefaces for every conceivable purpose is, in my book, one of the greatest advantages of the Internet. Refer to the Resources section for my favorite font-related websites. Some fonts are free; some may cost twenty dollars or even two hundred dollars. Fonts are not only fun, but having a well-stocked library of typefaces is an imperative if designing stationery is to be a significant part of your life. And if so, you'll probably want to install a font management program (e.g., Font Reserve) on your computer.

Designing with photos requires the use of clean typefaces that don't "fight" with the image. Weddings and special occasions call for styles that suit the flavor of the event, be it refined formality or casual elegance. Some fonts even come with charming decorative ornaments that are perfect for invitations.

These are a few of my favorite fonts.

This project emulates what is known as a full bleed, which means that there is no border—the image extends to the edge of the card. As most desktop printers don't print to the edge of the paper, we'll use a letter size sheet and, after printing, fold and trim it to a 5¼-inch square.

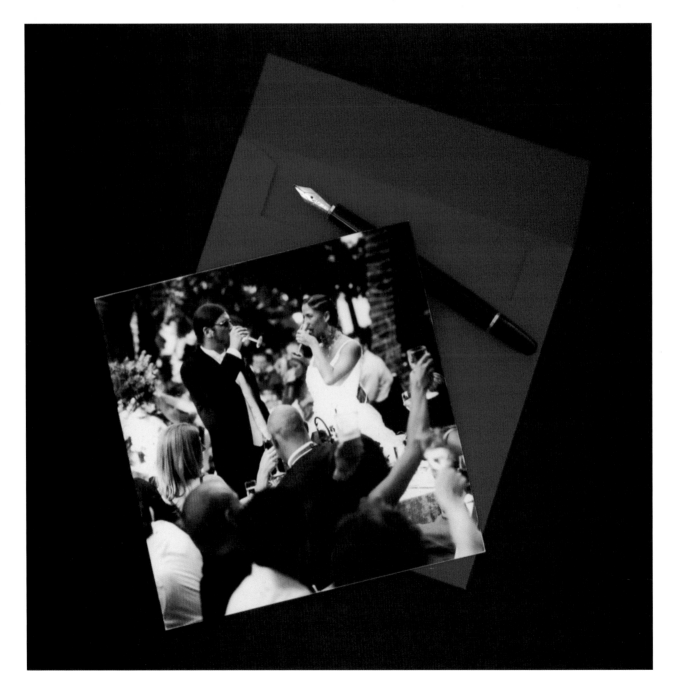

An authentic moment captured at the wedding reception provides the perfect image for a very personal thank-you note. A handmade envelope in a striking color enhances the black-and-white image.

1. Go to File>New and set up a custom size of 10½ inches wide by 5¼ inches high. The mode should be RGB or CMYK and the resolution 300 dpi. Save the new file as Template Square Card, but don't close the file.

2. In Page Setup, choose a letter-size file and a "land-scape" print orientation.

3. Under the View menu, make sure Rulers is checked. Drag out a vertical guide at 5¼ inches. As you work, at any time you can press Command plus the semicolon key (on a Mac) or Control plus the semicolon key (in Windows) to show or hide the guides. You can move the guides using the Move tool.

4. Now open the file containing the image you wish to use. Make certain the image is 300 dpi. If the photograph is not square, click on the Crop tool (C), and holding the Shift key down in order to maintain a square configuration, click and drag over the image to select the area you desire. Use the arrow keys to reposition the crop area as necessary. Press Return or Enter to complete the cropping.

5. Go to Image>Image Size and set the document size to 5¼ inches by 5¼ inches.

6. You can now copy and paste the image into the window you opened in step 1, or simply use the Move tool (V) to drag the image in until it snaps into place next to the guide-line on the right half of the layout as shown below. (If it doesn't snap into place, go to View>Snap to>Guides.) Close the original image file without saving it.

7. Click on the Type tool (T), and type your studio contact information in the area to the left that will become the back of the folded card. Select (highlight) the type to format it. Click on the Move tool, then use the arrow keys to move the type into position.

Dragging out a vertical guide.

Cropping the photo.

Use the back of the card to display your studio contact information.

8. To add a sentiment (e.g., "Thank You") to the inside of the card: Click the eye icon next to both the image and studio information layers in the Layers palette to make them invisible. Create a new text layer by clicking on the Type tool, and type the text in the right-hand side of the layout. Select the type to format it. Click on the Move tool, then use the arrow keys to move the text into position. (The Type tool is a little possessive . . . sometimes it just won't let go. Click on another tool to disengage it.)

9. Print the layout on letter-size paper.

10. Reinsert the paper in the printer by both flipping it over *and* rotating it.

11. In the Layers palette, click on the eye icons to make the image layer visible as well as the layer containing your studio info, and deactivate the layer containing the sentiment.

12. Print using the best photo settings.

13. Using the pointed end of a bone folder, score along the left edge of the image and fold along the score line. Place a piece of scrap paper over the fold and, using the flat edge of the bone folder, burnish to flatten the fold.

14. Trim to a 5¼-inch square.

Adding a simple text message to the inside of the card.

�֍ TIP

For double-sided printing, be sure to use printing paper designated as such. Printing on the "wrong" side is certain to produce a substandard result and may actually harm your printer. And if that isn't enough to dissuade you, many commercial papers contain corporate logos on the reverse side—not a pretty detail for wedding stationery.

THE BACK OF THE CARD

Offer your client the option of a personalized notation on the back of each printed piece, such as "Designed especially for Jim and Diane by . . . ," then insert your studio information.

If you can't print directly on the back of a piece (if, for example, you're using a watercolor paper or decorative backing sheet), print your contact information on a small (1¾- by ½-inch) Avery label and, centering it carefully near the bottom, affix it to the back of the card.

Here are the steps needed to produce two double-sided side-folding or top-folding cards out of one 8½- by 11-inch sheet of paper. These cards fit into a standard #5½ Baronial envelope, which measures 4⅜ by 5¾ inches.

❦ TIP

If it's difficult to visualize the mechanics of two double-sided folded cards on a flat computer screen, create a simple prototype by hand. Take a letter-size sheet of paper, and fold it to partition it into four equal segments. Label the front covers (1-Front and 2-Front), back covers (1-Back and 2-Back), and inside text (1-Inside and 2-Inside). Cut the sheet in half to make two "cards," and fold each card in half. Now your digital layout will make a lot more sense.

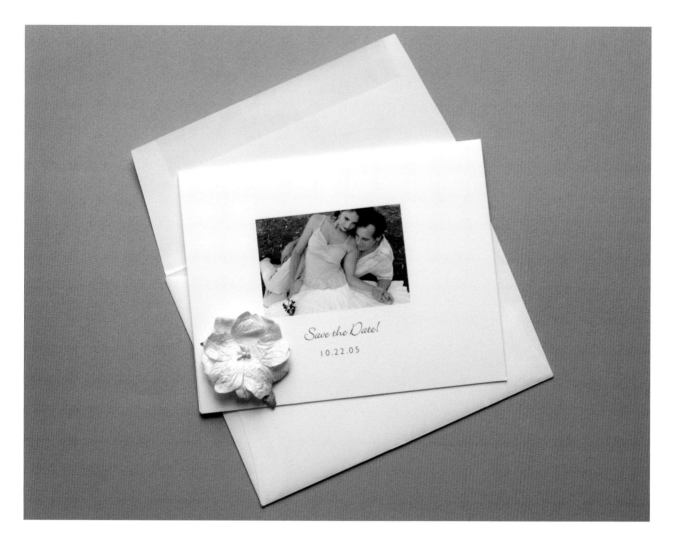

A simple yet elegant save-the-date card printed on ivory-colored fine art paper. The optional paper flower adds a personal touch. *(Fonts: Bickley Script and Arial)*

1. Choose File>New and select the Letter Preset option. For vertical side-folding card formats, use the normal "portrait" orientation; for horizontal top-folding formats, select a "landscape" orientation in the Page Setup menu, then go to Image>Rotate Canvas>90° CW.

2. Under View, make sure Rulers is checked. Drag out guides to partition the layout into four equal segments as shown.

3. Open an image file. Flatten the file if layered and crop or resize as needed. Make sure the resolution is 300 dpi. Go to Select>All, then Edit>Copy. Close the image file without saving.

4. Return to the open file by clicking on the window. Go to Edit>Paste. Use the Move tool (V) to position the first image as desired. Repeat Edit>Paste and move the second image into position in the second layout. Drag out additional guides and use the rulers to help align images within the layouts.

5. Add cover text by clicking on the Type tool (T). Choose a font style and size and type the text. Click on another tool (e.g., the Move tool) to deactivate the Type tool before going on to the next step.

6. To add your studio contact information on the back of each card, click on the Type tool again and type the pertinent details. (Don't worry about the placement at this point.) For horizontal card layouts only, go to Edit>Transform> Rotate 180°. Now move the info so that it will appear where you want it on the back of the first card—most likely centered or near the bottom. Go to Layer>Duplicate Layer and click OK, and move the second set of info into place in the second layout. (Use the arrow keys on your keyboard to coax it out of hiding immediately behind the first set.)

Layout for two vertical cards.

Layout for two horizontal cards.

Adding text to the front and back of the cards.

7. *Turn off the layers containing the cover text and images* and lay out the inside text for one card. To duplicate the inside text for the second card, go to Layer>Duplicate Layer and click OK. Then use the Move tool (V) and/or the arrow keys to move it into position in the second layout.

8. At this point, you'll have several layers—to avoid confusion, you might want to name them. In the Layers palette, highlighting each layer in turn, double-click on the layer and type in a description (e.g., Cover Image Card #1, or Inside Text Card #2). Or color code the layers as groups, say, differentiating the cover layers from the inside text layers. To do this, highlight each layer in turn, go to Layer>Layer Properties, and pick a color.

9. With only the cover layers activated, print one sheet.

10. Now turn off the cover layers and activate the inside text layers. Turn your paper over (but don't rotate it!), and print the second side.

11. Save the file.

12. Use a paper cutter or craft knife to cut the sheet in half, creating two cards.

13. Fold each card in half, then cover the fold with a piece of scrap paper and burnish with the broad edge of a bone folder to flatten smoothly. (For heavier card stock, use the pointed end of a bone folder to score a fold line before folding.)

❧ TIP

Depending on your printer, you may have to nudge the image or text layers a bit so that everything lines up perfectly. That's why it's imperative to always test print on inexpensive paper first. If you make any changes, be sure to save the tweaked version.

Adding text to the inside of the cards.

You can name, and even color code, the layers to help keep them all straight.

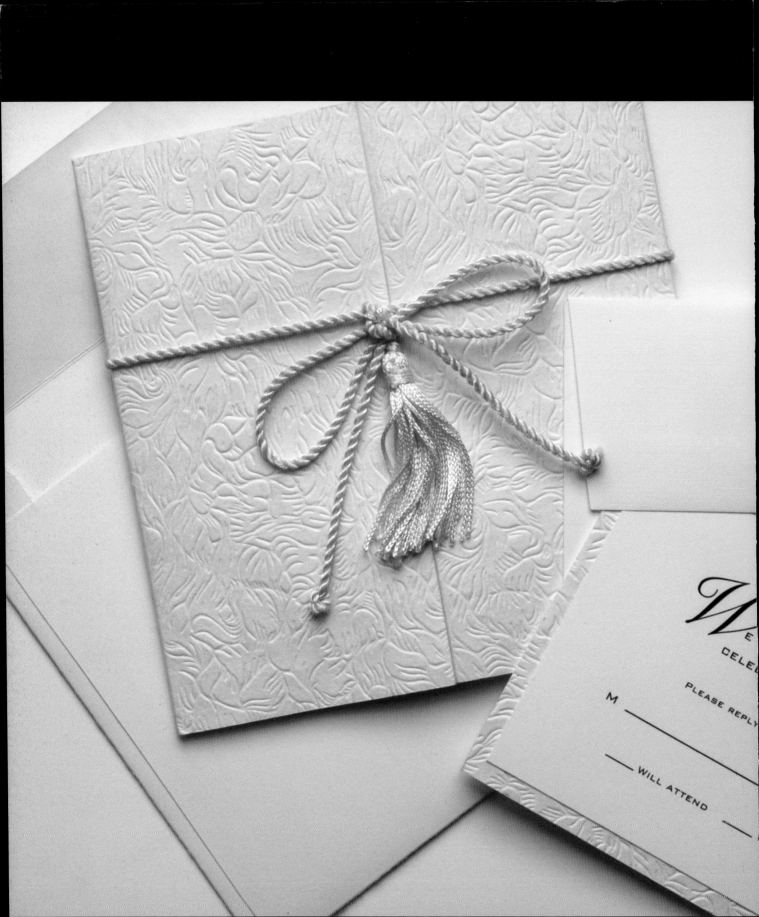

Chapter 7

THE WEDDING STATIONERY ENSEMBLE

Often ornate, always visually compelling, wedding invitations and the other elements that make up the wedding stationery ensemble are the crown jewels in the realm of personalized stationery. This chapter provides step-by-step instructions for several specific projects, but it should also serve as a springboard to inspire countless variations involving the use of imagery set off by elegant paper. Although you must be sensitive to the preferences of the couple about to be married, ultimately, it is your talent, creativity, and sense of style that will insure that the wedding papercrafts you produce will long be treasured as beautiful mementos.

The Creative Process

Although the strict guidelines have loosened in recent years, tradition still plays a large role in the overall design and text of wedding stationery. Nevertheless, there has been an explosion in the use of diverse materials and dynamic fonts to create wedding ensembles that perfectly reflect the personality and taste of individual brides and grooms.

Some new trends include:

- Eclectic specialty papers
- Tactile embellishments
- Square formats
- Oversized invitations
- The use of postcards in place of reply cards and envelopes
- Less formal language

When selecting wedding invitations, the couple or the bride-to-be—usually accompanied by her best friend, sister, or mother—pores over sample books, then chooses a style, color scheme, and typeface. But sometimes the image itself can suggest the design. A gentle, romantic image often calls for handmade paper and gauzy ribbon, while a traditional, elegant photograph may beg for the simplicity of a classic tailored invitation with clean lines.

Look at the photograph closely to absorb its nuances. Pull samples of printing paper, decorative paper, solid and patterned vellum; ribbon, cord, and string; and embellishments such as charms, feathers, shells, dried or fabric flowers, and skeleton leaves (delicate veined leaves stripped of green material through a special bleaching process). Place the various elements next to each other, then move things around, mixing and matching. Inevitably, the design concept springs forth as if it was there all the time, just waiting to be freed.

The hues and tones of the image will have a major impact on the decision. A color image demands embellishments that don't conflict; pick up one of the less prominent colors in the photograph to create a complement or accent. A black-and-white photo usually looks best with a rich solid color or two; tones of white, gray, and black; or metallics—gold, silver, copper, or bronze. A sepia-toned photograph may benefit from a simple white or off-white treatment. As a general rule, it's probably best to avoid busy patterns; however simple patterns—such as polka dots or stripes—can contribute to a dynamic design.

Before getting carried away by the vast array of possibilities, it's important to take a few moments to consider a few factors.

Finding just the right trimmings to complement a special paper is one of the most enjoyable aspects of creating wedding papercrafts.

Time Frame

Weddings are typically planned at least a year in advance of the big event, the idea being that it takes that long to make all the necessary arrangements, and also to give guests ample notice so that they don't make conflicting plans.

Invitations are usually mailed six to eight weeks prior to the wedding date; save-the-date cards may be mailed as early as a year in advance. Working backward from the wedding date, then, also give yourself plenty of time to locate and purchase the necessary materials and supplies, to enter the names and addresses of the guests into a database if you'll be addressing envelopes via the computer, and to assemble the various components.

Budgeting Your Time

Your skill level must also be taken into consideration. If you've never created a layout in Photoshop or used a paper cutter or craft knife, it will take some time for you to get the hang of it. But once you've made the first few pieces and finessed the "assembly line" aspect of the project, the remaining pieces will go much faster.

Pricing Guidelines

Hand-assembled papercrafts run the gamut from simple and cost effective to labor- and material-intensive (and thereby as costly as engraved or letterpress stationery). As enjoyable as it is to create custom designs, you probably want to make a profit as well. The price you charge depends on the materials you use, and how much time you spend on assembly. Here are some important guidelines to keep in mind when determining your prices:

There's a learning curve involved. As you become more experienced, it will take you considerably less time to complete a project.

Creating digital templates that you can use again and again by simply replacing the images and text will save you hours of time on future projects. Once you have perfected your layout and proofs, subsequent copies will stream off your printer, costing just pennies apiece, depending on the paper.

To determine your selling price, you must first break down your costs. When you buy a pack of paper, calculate how much each sheet costs. This can vary not only from paper to paper but according to the number of packs and size of paper you pur-

chase and where you buy it, especially if you order via the Internet. If you're adding ribbon, determine how much that ribbon costs per inch. The same goes for other embellishments. Keep track of these costs so you can refer to them again and again.

Now add up your costs, then multiply the total by at least two to determine the lowest possible selling price. If you work out of your home, this might be adequate. If the project is labor intensive, or if you have a high overhead (rent, utilities, employees), you might need to multiply by three or four or even five. Take your clientele into consideration; the price you set is often based on what the traffic will bear, or how you plan to position yourself in the marketplace. Do you want to be competitive with online services, or will you focus on a particular clientele in your own community, such as upscale, affordable, or budget?

I've found it helpful to use the two customized forms shown on the next two pages for each job— the first to keep track of my costs, and the other to use as a client worksheet/agreement showing my prices.

A GOOD RULE OF THUMB

Always plan on making at least ten to twelve extra cards, invitations, or announcements. Here's why:

- It may take several pieces to perfect the technique.
- There are almost always some rejects, such as misalignments or other flaws.
- You may end up needing a few more.
- You'll want to save some for your portfolio.
- You can use them as templates for your own personal spur-of-the-moment use.

COST ANALYSIS WORKSHEET

Job: _____

Date: _____

ITEM	COST PER PACKAGE/SHEET/TASK	COST PER PIECE
PAPER		
FOUNDATION		
PRINTING		
DECORATIVE		
OTHER		
ENVELOPES		
EMBELLISHMENTS		
RIBBON		
OTHER		
SPECIAL		
MESSENGERS		
SCANNING		
DATA INPUT		
ADDRESSING		
OTHER		
TIME/LABOR		
MEETINGS		
CONCEPT		
ASSEMBLY		
TRAVEL		
OTHER		
TOTAL:		

I use this worksheet to determine my costs, first setting down the cost of the entire package, sheet, or task, then dividing by the number of pieces to determine the cost per piece.

CLIENT AGREEMENT

Client: _____ Phone Number: _____ Submitted By: _____ Accepted By: _____

Order Date: _____ Date of Event: _____ Quantity: _____ Date: _____

		Version		
		1	2	3
FORMAT AND SIZE				
FLAT	BASE PRICE: $			
FOLDED (DOUBLE-SIDED)	BASE PRICE: $			
WRAP	BASE PRICE: $			
PHOTO TAG?	ADD $			
NEST	BASE PRICE: $			
POCKET	BASE PRICE: $			
BOOKLET	BASE PRICE: $			
ALBUM INVITE	BASE PRICE: $			
VELLUM COLOR:	ADD $			
PRINTED OVERLAY?	ADD $			
ATTACHMENTS				
RIBBON	ADD $ PER INCH			
FIBER	ADD $ PER INCH			
OTHER	ADD $ PER INCH			
OTHER EMBELLISHMENTS				
HANDMADE PAPER	ADD $			
SKELETON LEAF COLOR:	ADD $			
OTHER	ADD $			
SPECIAL FEATURES				
PHOTO	ADD $			
DIE-CUT WINDOW	ADD $			
OTHER	ADD $			
TYPEFACE				
FONT 1: COLOR:	NO CHARGE			
FONT 2: COLOR:	NO CHARGE			
MAILING ENVELOPE				
WHITE	NO CHARGE			
LINED	ADD $			
OTHER	ADD $			
ADDITIONAL ENSEMBLE COMPONENTS				
SAVE-THE-DATE CARD	ADD $			
REPLY CARD AND ENVELOPE	NO CHARGE			
MAP/DIRECTIONS/INSERT	ADD $			
PROGRAM/ITINERARY	ADD $			
TABLE CARDS/SEATING CARDS/PLACE CARDS	ADD $			
THANK-YOU NOTES	ADD $			
LABELS	ADD $			
ADDRESS ENVELOPES VIA DATA BASE	ADD $ PER GUEST			
ADDRESS LABELS VIA DATA BASE	ADD $ PER GUEST			
	PRICE PER CARD:	$	$	$

Breaking down the costs for several versions will help your clients make an informed decision.

The Ensemble: Piece by Piece

The components of a wedding stationery ensemble typically consist of the invitation and the response card. Additional components may include a save-the-date card, reception card, map card and/or directions; programs; table, escort, and place cards; menu cards; and thank-you notes. Even though the cornerstone of the ensemble—the wedding invitation itself—may feature a photograph, you probably won't want to use a photo on each and every element. Instead, tie everything together through the use of special papers, fonts, a color palette, or an overall theme.

Here's where your visual journal (see page 15) comes in. Create collages combining images, papers, fonts, and embellishments. When it comes time to design an ensemble, you'll have a library of ideas at your fingertips.

Invitation

The invitation tells the who, what, why, where, and when. With the proliferation of blended and non-traditional family structures, it's only natural that many of the phrases used in traditional wedding invitations have been modified. Listing the individual titles and names of several parents can easily detract from the names of the star players. These days, it's not uncommon for the bride and groom themselves to extend the invitation along with—or without—their parents. Generally speaking, avoid abbreviations (except for Mr. and Mrs.) and spell out the numbers in days, dates, and times. Most invitations include a brief reference to the reception; many also mention preferred attire (e.g., black tie, casual elegance, cocktail).

There are a number of ways in which an invitation can be worded. The bride's parents inviting . . .

The bride's and the groom's parents inviting . . .

The bride and the groom, with their parents or families, inviting . . .

The bride and groom inviting . . .

Inner Envelope

An extra envelope in which the invitation components are placed before being inserted into a mailing envelope, the inner envelope adds to the weight— both emotional and physical—of the occasion. A sheet of vellum or sheer paper is sometimes inserted as well. Inner envelopes are a good idea when invitations include embellishments, such as shells or charms, that could be damaged in the mail. They're also an opportunity to reinforce the design theme through the use of special papers. Once traditional, they are no longer considered essential.

Save-the-Date Card

The save-the-date card is a thoughtful way of notifying guests of the wedding date and location well ahead of time—three to twelve months—so they're able to plan accordingly. They are especially appropriate for destination weddings and those for which guests will be coming from out of town. Often a simple flat card, save-the-date cards can also take the shape of an elaborate program of events, travel routes, and suggested accommodations, although they are definitely not a substitute for the invitation itself.

5.21.05

PLEASE SAVE THE DATE
FOR THE WEDDING OF

Ivy Lundeen

and

Vern Willhite

SANTA BARBARA, CALIFORNIA

INVITATION TO FOLLOW

Some save-the-date cards offer the barest essentials in terms of information. This save-the-date card slips neatly into a 4⅛- by 9½-inch open-end envelope.

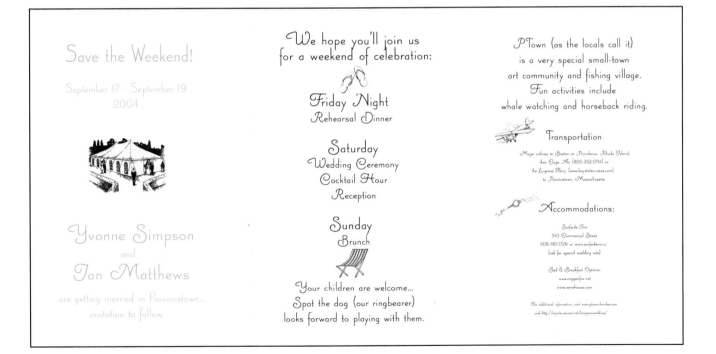

Some save-the-date cards are essentially brochures, complete with a schedule of events as well as suggested travel routes and accommodations. This three-panel card fits into a #5 Baronial envelope when folded.

Response Card and Envelope

The formal equivalent of an RSVP, some response cards also include a menu selection. Postcards have recently become an informal option. The envelope or postcard should be printed with the name and address of the bride or other appropriate person, with postage applied.

We look forward to celebrating with you!

Please respond by June 5, 2005

M _____

Accepts Regrets

_____ _____

Number of Guests ____

POSTAGE
STAMP
HERE

SPECTOR-RABIN

301 NO. CAMDEN DRIVE

BEVERLY HILLS, CA 90210

Please respond by September 7th

_____ Yes, we will be attending
_____ No, we cannot attend

Choice of Entree
☐ Steak ☐ Salmon

We look forward to celebrating with you!

Two styles of response cards. Some people forget to fill in their names, or their handwriting may be eligible, so you may want to discretely number each response card to correspond with a numbered guest list. *(Fonts: left— P2 Da Vinci and Bauhaus; above—Bauhaus.)*

Direction/Map Cards

These cards contain easy-to-follow directions to the wedding and, when appropriate, the reception site. They may also include travel and accommodations information for out-of-town guests.

DIRECTIONS TO THE FOUR SEASONS BILTMORE - SANTA BARBARA, CA

FROM LOS ANGELES INTERNATIONAL AIRPORT VIA THE FREEWAYS:
- FOLLOW SIGNS TO 405 FREEWAY NORTH.
- CONTINUE 405 NORTH TO 101 FREEWAY NORTH.
- DRIVING TIME IS APPROXIMATELY 1 1/2 - 2 HOURS.
- EXIT AT OLIVE MILL ROAD AND TURN LEFT.
- FOLLOW ROAD 1/2 MILE...THE FOUR SEASONS BILTMORE IS LOCATED ON YOUR
 RIGHT-HAND SIDE, ACROSS FROM THE OCEAN.

FROM LOS ANGELES INTERNATIONAL AIRPORT VIA THE COASTAL ROUTE:
- DRIVE ON LINCOLN BOULEVARD NORTH TO 10 WEST (DIRECTION SANTA MONICA).
- THIS WILL PUT YOU DIRECTLY ONTO THE PACIFIC COAST HIGHWAY NORTH.
- THE PCH JOINS FREEWAY 101 NORTH AT THE CITY OF OXNARD.
- TAKE THE 101 NORTH TO THE OLIVE MILL ROAD EXIT.
- TURN LEFT TOWARDS THE OCEAN. WHEN YOU SEE THE OCEAN ON YOUR LEFT, THE ENTRANCE
 TO THE RESORT IS ON YOUR RIGHT.

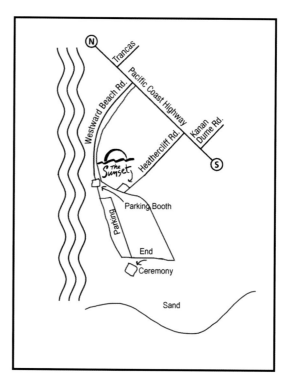

The invitation informs guests of the location of the event, but including a map or directions is a courtesy to assist them in getting there. *(Font: Mrs. Eaves)*

Program

Wedding programs are becoming more and more popular. Handed out shortly before the ceremony begins, the program usually lists the names of those in the wedding party and a chronology of events. Although not required, it's a nice way to keep everyone involved and informed. A wedding program can be one page, multiple pages held together with a tassel or ribbon, or even a tied scroll.

Reception Card

Separate reception cards are typically used when (a) the ceremony and the reception are being held at different locations, or (b) the number of guests invited to the reception is greater than the number of those invited to the wedding, in which case certain guests will also receive an announcement in place of an invitation. If the reception is being held at the wedding site, you can simply add the information at the bottom of the invitation.

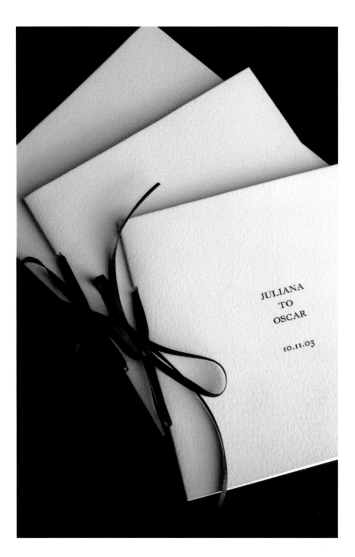

Destined to become a sentimental keepsake, this program includes a photograph, a personal message from the bride and groom, and a poem. *(Font: Letterpress Text)*

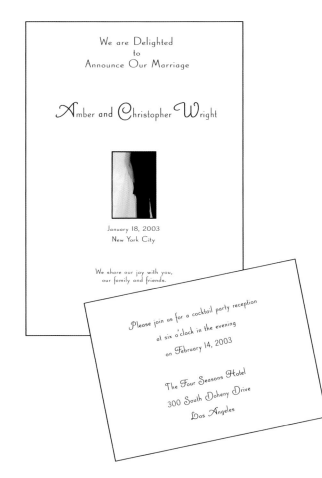

A marriage announcement and separate reception invitation. Some receptions are held on a different day than the wedding, and many couples get married in exotic or far-off locations or in their hometowns, then hold a reception upon their return to the city in which they live. *(Font: Canterbury)*

Table, Escort, and Place Cards

These cards let guests know where they are to be seated at the reception. Usually set up just outside the reception area, each escort card bears the name of a guest and his or her table number. Numbered table cards are located on the tables themselves and often incorporated into the centerpieces. Individual place cards are placed at each setting.

Menu Cards

For formal sit-down receptions or buffets, menu cards simply list the courses served, sometimes with a brief description.

Thank-you Cards

A thank-you card should be sent to each guest shortly after the wedding. It's the perfect place for a favorite photograph from the event. The inside is usually blank or printed with a brief thank-you, affording sufficient space to accommodate a hand-written note.

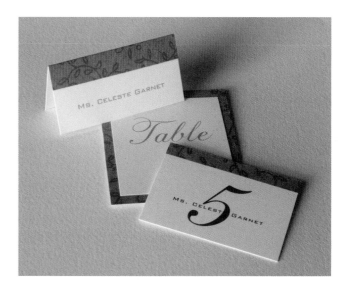

A piece of decorative paper is glued to each component to create an coordinated ensemble. From top to bottom: place card, table card, and escort card. *(Fonts: Shelley Allegro and Bank Gothic Light)*

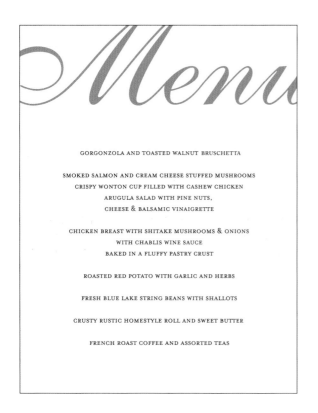

GORGONZOLA AND TOASTED WALNUT BRUSCHETTA

SMOKED SALMON AND CREAM CHEESE STUFFED MUSHROOMS
CRISPY WONTON CUP FILLED WITH CASHEW CHICKEN
ARUGULA SALAD WITH PINE NUTS,
CHEESE & BALSAMIC VINAIGRETTE

CHICKEN BREAST WITH SHITAKE MUSHROOMS & ONIONS
WITH CHABLIS WINE SAUCE
BAKED IN A FLUFFY PASTRY CRUST

ROASTED RED POTATO WITH GARLIC AND HERBS

FRESH BLUE LAKE STRING BEANS WITH SHALLOTS

CRUSTY RUSTIC HOMESTYLE ROLL AND SWEET BUTTER

FRENCH ROAST COFFEE AND ASSORTED TEAS

Menus are sometimes put at individual place settings or framed and displayed at each table or at the buffet table. *(Fonts: Shelley Allegro and Mrs. Eaves)*

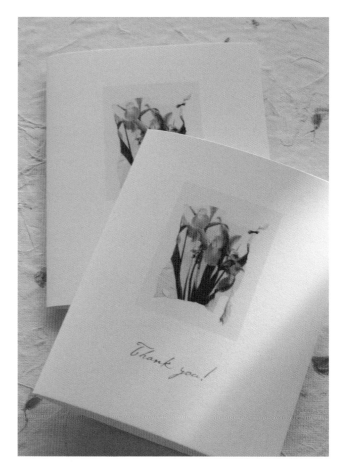

This thank-you note features one of my personal "stock" photographs, which was transformed into an emulsion lift (see page 73) and scanned. *(Font: P22 Cezanne)*

Creating the Ensemble: Step by Step

When designing with photography, choose imagery with strong composition that communicates effectively at first glance, whether evoking a mood or telling a story. Once the decision has been made as to the photograph(s) to be used, follow these steps to create the final ensemble.

Step 1: Choose a Motif

The ensemble should have a motif, or design theme, be it traditional, luxurious, eclectic, or something else. Deciding on a central theme and carrying it through all elements of the ensemble establishes a motif. A traditional invitation features classic typefaces and white or ivory papers and envelopes. Integrating colorful textured vellum or watercolor paper with a deckled edge are two stylish ways to update a traditional theme. Adding silky ribbon or braided cord and tassels to an oversized invitation communicates luxury and opulence. Incorporating handmade paper, collage, distinctive fonts, and diverse embellishments will result in an eclectic invitation tailored to reflect the unique personality of the couple involved.

Step 2: Choose a Size

Each element of the ensemble that is to be mailed should fit comfortably into the standard envelopes found at stationery and paper supply stores as well as online. (See page 128 for more about envelopes.)

Step 3: Choose a Format

Decide on a format for the invitation. This chapter provides step-by-step instructions for some of the most popular formats—wrapped ensembles, pockets, nests, and layered booklets. (See "Types of Ensembles" on page 115.)

Step 4: Choose Papers and Card Stock

Follow the guidelines laid out in Chapter 5, "Papercrafting," to select papers that are appropriate for the ensemble you are creating. Depending on the format you've chosen, you'll need suitable paper for the cover or background, printing the image and text, and any other decorative treatments.

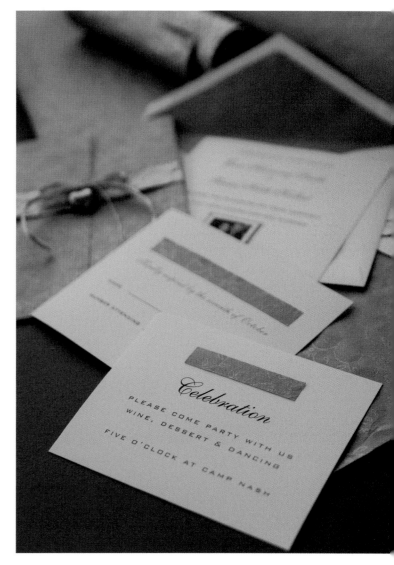

This elegant ensemble features beautiful handmade paper used as an accent to complement the crinkled gold *momi* paper wrap. *(Fonts: Shelley Allegro and Bank Gothic Light)*

Step 5: Choose Fonts

I like to use an easy-to-read typeface for the main body of text, accented by a contrasting face for special names (e.g., the bride and groom) or other words. Carry the choice of fonts through to all components of the ensemble.

Serif typestyles have little lines at the ends of the letter strokes; sans serifs do not (*sans* is French for "without"). Script typefaces emulate handwriting. In traditional wedding invitations, the body of the invitation features what is known as an old-style serif font, while the names of the bride and groom are often set in a larger calligraphic-style script. The initial capital letters of the names can be significantly enlarged, or the color changed, to add a dynamic sense of style to the design. Some fonts include swashes, ligatures, and flourishes.

Step 6: Choose Embellishments

For a truly one-of-a-kind design, choose embellishments that enhance the photograph and complement the motif, such as ribbon, cord, waxed linen thread, string, raffia, or fiber. Depending on the theme of the wedding, you might want to add shells, skeleton leaves, charms, feathers, or eyelets. Just don't go overboard; less is often more. If the ensemble is bulky or there's a risk of breakage en route, mail it in a flat box instead of an envelope.

Some women covet shoes; a peek into one of my many boxes of ribbon reveals my passion.

🌿 TIP

Some of us can't tie a pretty bow to save our soul. Wired ribbon makes it easy to turn almost any bow into a work of art—just tie it, then scrunch it and smoosh it. It actually looks best when it's not perfect! A shoelace bow, as the name implies, is tied just as you would your shoelace. Sometimes, it helps to turn the piece upside down when tying the bow so that the ends hang down.

Ribbons, cords, and other types of fibers are available in myriad widths, colors, and textures. You can find one that will provide the perfect complement to any invitation.

Ensemble Formats

There's much to be said about the classic elegance of a simple flat wedding invitation featuring time-honored typefaces and printed on rich creamy card stock. Follow the instructions provided in Chapter 6, "Creating Digital Layouts," and lay out the invitation on the finest quality printing paper. If you can, conserve time and materials by printing two layouts side by side on an 8½- by 11-inch sheet.

While a flat card can certainly stand on its own, it also serves as the basis for the invitations detailed in the pages that follow—wrapped ensembles, nest-style envelopes, pocket cards, and layered booklets.

Simply wrapping an ensemble in tulle is a fun alternative to creating a paper wrap (see page 116).

This deluxe hinged album invitation is a variation on the classic hardcover album project on page 143. Simply lay it out to fit a standard envelope size and substitute two pieces of lightweight cardboard for the book board. This type of ensemble is just the thing for a destination wedding because you can add as many pages as needed to include travel and lodging information, itineraries, maps, and more.

THE WEDDING ENSEMBLE WORKFLOW

Follow these steps when assembling a wedding ensemble to ensure an efficient workflow:

1. Print all text and image components.
2. Cut all materials and components to size.
3. Mount any printed components on corresponding card stock.
4. Assemble the ensemble.

In assembling ensembles other than pocket cards and booklets, all enclosures should be placed behind the invitation, printed side up, including the response card, which is placed under the flap of its own envelope, not inside it. The assembly is then inserted into the mailing envelope so that the printed wording is face up when the envelope is opened and the invitation is pulled out.

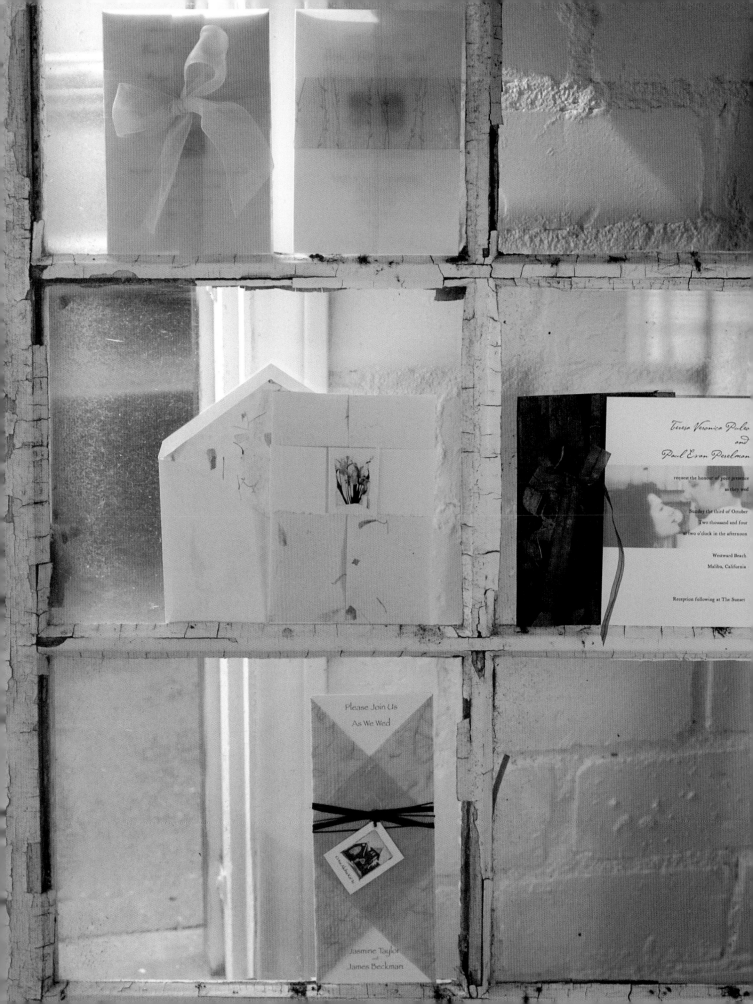

The wrap, which is often made of vellum or fine handmade paper, in a sense replaces the traditional inner envelope. A complementary binding or band holds the components of the ensemble together. Choose a size that fits into a standard mailing envelope. To enhance the visual impact, line the mailing envelope with the same decorative paper as the wrap.

MATERIALS

Heavy photo-quality printing paper such as Arches Infinity Smooth 230 g/m² or 355 g/m²; or use a lighter weight paper and fuse it to card stock with spray adhesive

Specialty or decorative paper for the wrap

Paper cutter or craft knife

Bone folder

Straightedge or ruler

Cutting mat

Ribbon or cord

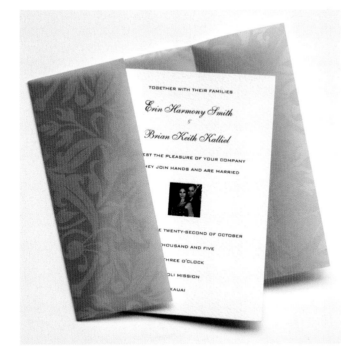

This stylish gatefold-wrapped invitation combines the traditional simplicity of a flat card with a contemporary application of textured vellum.

OPPOSITE: Vellum and handmade paper wraps are enhanced by complementary ribbon, raffia, bands, and lined envelopes.

Basic Wrap

1. Lay out and print the invitation and additional components (e.g., response card) on the printing paper. Cut to size.

2. Use a paper cutter or craft knife to cut the wrap out of the specialty or decorative paper. The height should be equal to that of the printed invitation; the width should be twice that of the invitation, plus ¼ inch or so for overlap (optional).

3. Center the invitation on top of the wrap, placing any additional components behind it, then fold the wrap around the ensemble, creating a gatefold. Experiment to find the placement you like best; you may prefer the opening off center.

4. Bind the entire assembly with ribbon, cord, and/or a band as shown below.

CUSTOM PHOTO TAG

Instead of including a photograph on the invitation itself, you might prefer to attach a custom photo tag to the binding or to a band. Save time and money by laying out and printing multiple photos on one sheet of paper.

Print an image about 1 inch in height on photo-quality printer paper and cut it to size. Apply double-sided tape to the back of the photo, and mount it onto a piece of watercolor paper or card stock. Trim, leaving a narrow border around the image. Attach an eyelet, thread a piece of ribbon or cord through it, and tie it around the wrap or glue it onto a band.

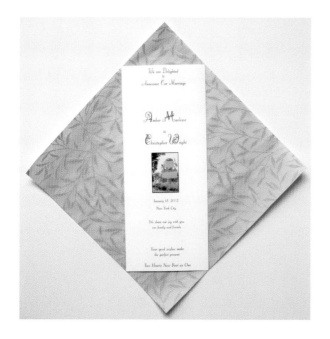

Placement of the invitation on the tall wrap.

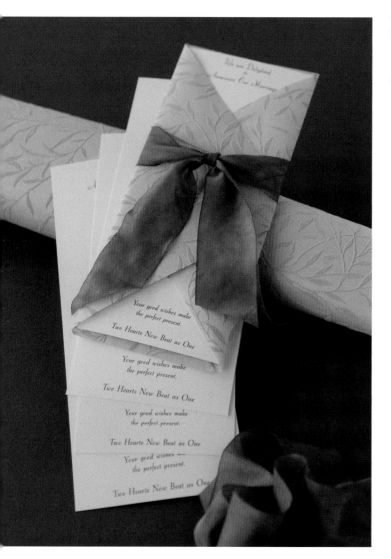

Tall Wrap

For a contemporary look, make a bold statement with a tall diagonal wrap. To complete the look, slide it into a $4\frac{1}{8}$- by $9\frac{1}{2}$-inch envelope that features a flap at the narrow end. The materials needed are the same as for the basic wrap.

1. Create a $3\frac{7}{8}$- by $9\frac{1}{4}$-inch page layout for the invitation, print, and cut to size. Print and cut out additional enclosures as well.

2. Cut a piece of decorative paper to $9\frac{1}{4}$ by $9\frac{1}{4}$ inches.

3. Place the invitation on the paper and center it on the diagonal, making sure the corners precisely meet the edges of the paper. Fold the left side of the paper over toward the right and around to the back, then the right side over to the left and around to the back so that they overlap in the middle.

4. Rather than cutting off the excess paper at the top and bottom, fold it inward, tucking it behind the invitation, and glue down; this forms finished edges and adds stability.

5. Insert enclosures behind the invitation and bind the entire assembly with ribbon or cord.

Flocked paper and hand-dyed ribbon combine for a sophisticated ensemble. Note that the invitation text was laid out so that the top and bottom phrases are perfectly framed by the wrap.

BANDS

A band is a versatile decorative and functional element. It can be used to hold the components of a flat invitation ensemble together, or to hold a wrapped ensemble or pocket invitation closed as an alternative to, or in addition to, ribbon or cord. Make a band out of wide ribbon or decorative paper and secure the ends with glue or double-sided tape. You can wrap the band with adornments such as ribbon, raffia, metallic cord, wire, or fiber. For an added embellishment, attach a charm, beads, shells, or a custom photo tag (see instructions on page 117).

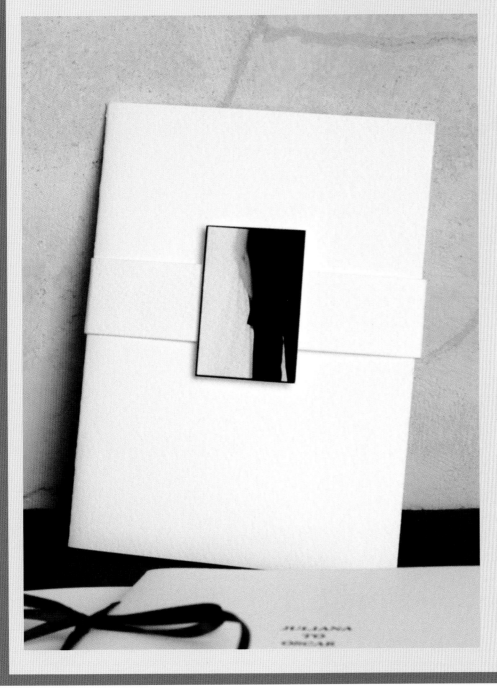

This is a simple folded card with the invitation printed on the inside. The epitome of classic simplicity, a minimalist black-and-white image is enhanced by textured fine art paper. A photo tag is glued directly onto the band that encircles the ensemble.

Evelyn and Theodore Samuels together
with Carolyn and Edward Neumann
request the honor of your presence at
the marriage celebration of their children

Amy Samuels
and
John Neumann

on the twenty-fifth day of September
two thousand and four at four o'clock
at The Peninsula Hotel in Beverly Hills,
California - Dinner reception to follow.

SAMUELS
575 NO. CRESCENT DR.
BEVERLY HILLS
CALIFORNIA
90001

Please ... August

☐ accept with pleasure
☐ decline with regret

A "nest" envelope allows you to enfold a number of enclosures in a charming presentation. Similar to a regular envelope, it's made from heavier stock, and there's no glue involved. All flaps have the same dimensions. Just fold the flaps in—sides first, then bottom, then top—and seal with a reinforced return address label. The envelope should be at least an $\frac{1}{8}$ inch larger all around than its contents to ensure that it will fold properly.

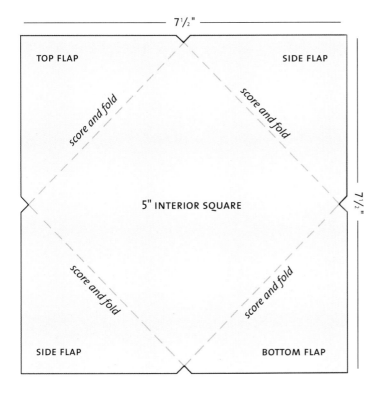

Nest envelope template.

MATERIALS

A printed wedding ensemble featuring
 a 5-inch square invitation
Nest envelope template
Watercolor or textured paper such as
 Canson Mi-Teintes
Paper cutter or craft knife
Bone folder
Straightedge or ruler
Cutting mat
Sturdy return address label (see page 125)
 or sealing wax and seal
Ribbon, raffia, waxed linen thread, or
 cord (optional)

1. Trace the nest envelope template onto a piece of watercolor or textured paper and cut out. Cut out notches as indicated.

2. Use the pointed tip of a bone folder to score along the fold lines. Fold the flaps inward. Covering each folded edge in turn with a piece of scrap paper to prevent shininess, sharpen creases somewhat by using the broad edge of the bone folder to burnish.

OPPOSITE: Mold-made paper, a font that mimics the look of letterpress, sepia tones, and colorful waxed linen thread all add up to a distinctive ensemble with a classic yet contemporary flair. *(Fonts: P22 Cezanne and Letterpress Text)*

3. Insert the wedding stationery ensemble. Optionally, first tie the components together with ribbon, raffia, or cord. My personal favorite is waxed linen bookbinding thread, which is now available in a variety of colors.

4. Close the envelope by attaching a sturdy return address label. For a different look, you could use sealing wax or eyelets and string, then insert the whole thing in a separate mailing envelope.

Decorative paper with a checkerboard pattern is used to create a border motif that ties together the components of this square pocket ensemble. Here, the photo is sized to fit the horizontal top panel and affixed to the invitation. The text is printed on a piece of paper that is adhered to the body panel. *(Fonts: P22 DaVinci and Bauhaus)*

Teresa Veronica Puleo
and
Paul Evan Perelman

request the honour of your presence
as they wed

Sunday the third of October
Two thousand and four
at two o'clock in the afternoon

Westward Beach
Malibu, California

Reception following at The Sunset

Please respond by September 7th

_____ Yes, we will be attending
_____ No, we cannot attend

Choice of Entree
☐ Steak ☐ Salmon

We look forward to celebrating with you!

Pocket Card Ensemble

Contemporary and practical, pocket invitations are one of the most popular innovations in wedding stationery, and they lend themselves to almost any style of decoration. You can create a square or rectangular format with a vertical or horizontal orientation, and you can print text right on a screened-back photo or feature the photo as a separate element. Add a vellum overlay if you like. Play with the myriad possibilities.

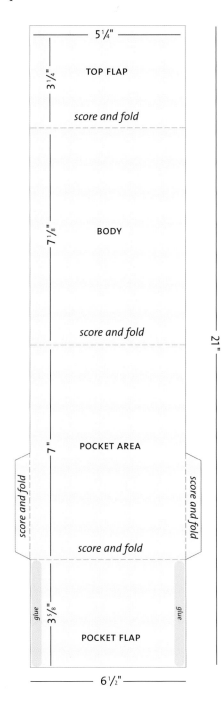

MATERIALS

Photo-quality fine art printer paper
Watercolor paper or good card stock
Square or rectangular pocket card template
Paper cutter or craft knife
Bone folder
Straightedge or ruler
Cutting mat
Double-sided tape or glue
Sturdy return address label (see page 125)

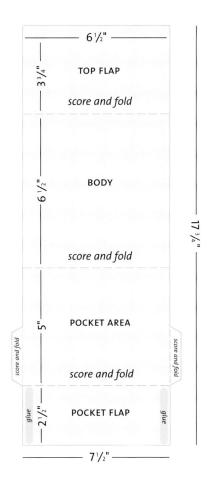

Rectangular pocket card template. Square pocket card template.

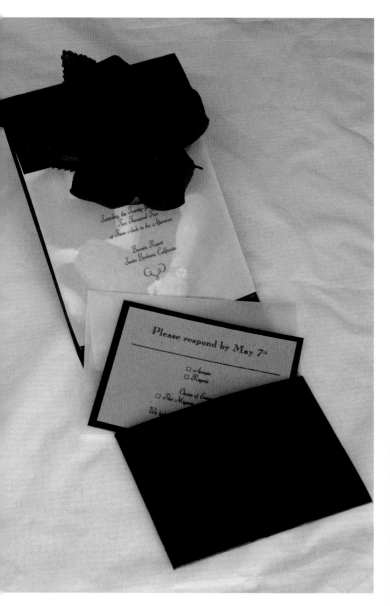

1. Copy or trace the square or rectangular pocket template onto a piece of watercolor paper or good card stock. Mark the fold lines with pencil dots.

2. Cut out.

3. Score along the fold lines and fold the flaps inward. Sharpen creases by using the broad edge of the bone folder to burnish, covering each folded edge with a piece of scrap paper before burnishing to prevent shininess.

4. Apply glue or double-sided tape to the edges where indicated and adhere to the flaps to create the pocket. Place under a weight and allow adhesion to set undisturbed.

5. Add an image and text in any of the ways shown in Chapter 6, "Creating Digital Layouts."

A milliner's flower and vellum accents are featured in this elegant black-and-white rectangular pocket ensemble. Here, the photo is adhered to the body panel of the invitation and revealed beneath an overlay of printed vellum. Alternatively, screen back the photo and print directly on it. (See page 67 for instructions on screening back photos.)

Many pocket invitations are perfect for mailing as is with the addition of a sturdy mailing label. If you've attached three-dimensional objects such as millinery flowers, mail the invitation in a little gift box for a special presentation.

RETURN ADDRESS LABELS

To create sturdy return address labels, lay out and print a page of oversized return address labels on heavyweight matte printing paper, then cut each to size. Cut placards slightly larger than the labels out of watercolor paper or heavy card stock. Adhere the labels to the placards with double-sided tape or glue.

To attach a label, apply two strips of double-sided tape with a peel-away backing. Remove the backing from one strip and adhere the label to the tip of the top envelope flap; leave the backing in place on the second strip until it's time to seal the envelope.

Create a layout as shown to print multiple return address labels.

These reinforced address labels are more than functional: They add a decorative element to nest-style (see page 120) and pocket (see page 122) ensembles.

Layered booklets are ideal for save-the-date cards and destination weddings where a lot of information needs to be communicated. For save-the-date cards, use colorful paper for the backing, simple or whimsical embellishments, and lay out the text using informal fonts. For wedding invitations, incorporate elegant papers and embellishments, and choose more formal fonts.

MATERIALS

Watercolor paper or sturdy card stock for the
 backing sheet; or adhere decorative paper to
 sturdy card stock using spray adhesive
Complementary decorative or textured paper
 for the cover (or use the same paper as above)
Printing paper for the inside pages
Paper cutter or craft knife
Bone folder
Straightedge or ruler
Cutting mat
Fastening material—ribbon, waxed linen thread,
 or braided cord
Hole punch with a diameter appropriate to your
fastening material, commonly $\frac{1}{8}$ inch

Layered booklet invitations can be casual or eclectic.

MAKING A PUNCH TEMPLATE

To make a punch template, take a piece of heavy card stock the same width as the backing sheet. Score a fold line 1 inch from the top edge, and fold along the scored line. Measure and punch holes through both layers equidistant from the folded top and outer edges. Spread the template open and place it over the top (unfolded) edge of the backing sheet, aligning the side edges, and punch through the four holes.

Make your punch template out of sturdy cardboard so that you can use it again and again. It will be an invaluable aid in making sure all the holes line up properly—very important for a professional-looking piece.

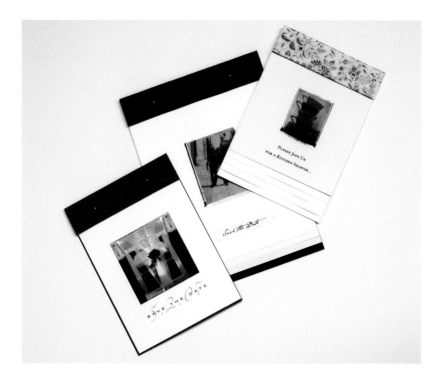

Simple, clean layouts add up to sleek, chic booklets.

❧ TIP

You can also include a detachable response card. Lay out the page, making sure that it meets U.S Postal Service size requirements (see page 129). Incorporate a dashed line along the top end of the layout. Print this page on heavyweight matte printing paper, then perforate it manually using a Fiskars rotary paper perforator.

1. Choose an envelope size. Out of the sturdy card stock, cut a backing sheet measuring ½ inch less in width and height than the envelope, adding 1 inch for the flap at the designated top edge of the booklet.

2. Score a fold line 1 inch from the top (narrow) edge.

3. Use a punch template (see previous page) to punch four holes, then fold along the scored line.

4. Excluding the front cover for now, you might want to include a photo and/or a poem or the lyrics to a song on the first page, the main text on the second, a schedule of events on the third, and a detachable map or response postcard on the last page (see "Tip").

Working backward, lay out and print each page, keeping in mind that the top inch will be hidden under the backing flap, that the bottom edge of the last page should fall ¼ inch above the bottom edge of the backing, and that each page should be ¼ inch longer than the page that will come before it.

5. Cut out a cover that is the same width as and ¼ inch shorter than the first page.

6. Now, using the folded backing as the punch template, and *aligning all of the page tops,* punch through the holes of the backing and into the cover and all the pages.

7. Assemble the booklet and tie the pages together.

VARIATIONS

Layered booklets offer a world of possibilities in terms of decoration—keep it simple, or go over the top!

- Lay out the cover to include a photo, then print it on fine art printing paper, or print a photo separately and mount it onto the cover.
- Attach eyelets to the punched holes.
- Alternate the interior paper colors.
- Add blank divider pages of natural or colored vellum.
- Attach a twig or reed as a cover ornament, perhaps wrapped with ribbon or wire.
- Add beads or charms to the ribbon or cord used to tie the page together.
- Gild the bottom edge of all pages (see page 88).

Envelopes

Premade envelopes are available in many sizes, shapes, colors, and styles. The Internet is a great resource for finding just the envelope you need. You can customize purchased envelopes by lining them with decorative paper (see page 131) or, alternatively, make them from scratch (see page 130).

Types of Envelopes

The following is a list of standard envelope designations and sizes. The smaller sizes listed are most appropriate for response and thank-you cards.

ANNOUNCEMENT ENVELOPES

These envelopes are commonly used for cards and invitations. The flaps can be pointed, flat, or deckled.

Item #	Size
A-1	$3^5/_8$ by $5^1/_8$ inches
A-2	$4^3/_8$ by $5^3/_4$ inches
A-6	$4^3/_4$ by $6^1/_2$ inches
A-7	$5^1/_4$ by $7^1/_4$ inches
A-8	$5^1/_2$ by $8^1/_8$ inches
A-9	$5^3/_4$ by $8^3/_4$ inches

BARONIAL ENVELOPES

So-called baronial envelopes are considered more formal, are deeper, and typically feature a pointed flap.

Item #	Size
2 BAR	$3^3/_{16}$ by $4^1/_4$ inches
4 BAR	$3^5/_8$ by $4^5/_8$ inches
5 BAR	$4^1/_8$ by $5^1/_8$ inches
$5^1/_4$ BAR	$4^1/_4$ by $5^1/_4$ inches
$5^1/_2$ BAR	$4^3/_8$ by $5^5/_8$ inches
$5^3/_4$ BAR	$4^1/_2$ by $5^3/_4$ inches
6 BAR	5 by 6 inches
LEE	$5^1/_4$ by $7^1/_4$ inches

SQUARE ENVELOPES

Square envelopes are considered specialty envelopes, but their growing popularity—despite the fact that they require additional postage—has made them easier to find. The most common sizes are:

5 by 5 inches
$5^1/_2$ by $5^1/_2$ inches
6 by 6 inches
$6^1/_2$ by $6^1/_2$ inches
7 by 7 inches
$7^1/_2$ by $7^1/_2$ inches
8 by 8 inches
$8^1/_2$ by $8^1/_2$ inches

OPEN-END ENVELOPES

A new trend in wedding stationery, they measure $4^1/_8$ by $9^1/_2$ inches and feature a flap at the narrow end.

Addressing the Envelopes

If you are in charge of addressing envelopes, you'll want to keep careful track of who has been sent what, and when, especially if save-the-date cards are included.

Typically, the guest list undergoes numerous modifications. Instead of jotting down notes on scraps of paper, be sure to mark any changes on the "master" list so that everything is crystal clear. Tradition dictates the following guidelines, but individual preferences always prevail:

- Use full names preceded by titles (Mr., Mrs., Ms., Miss, Dr.).
- If inviting a couple with different last names, include both full names and titles.
- If inviting a married couple with different last names, or an unmarried couple living together, put names in alphabetical order by last name.
- For a family, address it to the parents' names followed by the first names of the children who are invited, in order of age beginning with the oldest. Alternatively, address it to the couple "and family."
- If inviting a single person, address it to that person or to the person "and guest" when appropriate.
- Don't use symbols; spell out the word *and*.
- Don't use abbreviations, except for titles.
- Spell out street names, cities, and states. Spell out *Street, Avenue,* and *Boulevard.*
- Use figures for house and apartment numbers as well as zip codes.

Note: When inner envelopes are included, only the titles and surnames should be written, followed by, when applicable, the children's first names or, in the case of a single person, "and guest" if appropriate.

GUEST LIST

	Title	First Name	Last Name	Add'l. Names	Address	City	State	ZIP Code	Save-the-Date Sent	Shower Invite Sent	Wedding Invite Sent
1											
2											
3											
4											
5											
6											
7											
8											
9											
10											

Client: _____

Contact Number: _____

I use the data merge function in Microsoft Word to create a guest list/log such as this one for addressing envelopes, but if you're not going to address envelopes using a database, you could use the simpler table function or a spreadsheet program.

Mail and Postage Considerations

According to United States Postal Service regulations, the following items require extra postage:

- Square envelopes
- Pieces with a string closure or clasp
- Pieces weighing more than one ounce
- Pieces requiring hand canceling (to keep the envelopes neat, and to protect breakable items)
- Pieces with a height exceeding 6⅛ inches, a length exceeding 11½ inches (length is the dimension parallel to the address), or a thickness exceeding ¼ inch
- Pieces in which the length divided by the height is less than 1.3 or more than 2.5

Reply envelopes or postcards must be:

- At least 3½ by 5 inches
- No larger than 4¼ by 6 inches
- Printed on 65- to 80-pound paper

For further information, go to www.usps.com.

Handmade Envelopes

If you enjoy making your own envelopes, create a library of different-size envelope templates out of heavy card stock that you can use over and over again.

MATERIALS

A premade envelope to use as a template
Heavy card stock for the new template
Paper for the envelope
Glue stick or double-sided tape
A paper cutter and/or craft knife or scissors
Bone folder

1. Take apart a premade envelope of the appropriate size, position it on the heavy card stock, and trace around it. Mark fold lines and cut it out to use as a template.

2. Position template on the paper and trace around it, marking fold lines with pencil dots, then cut out.

3. Using a ruler, align the dots and score along the fold lines with a bone folder.

4. Fold and assemble, burnishing the folds with the broad edge of the bone folder.

5. Adhere edges with glue stick or double-sided tape, leaving flap to be sealed after contents have been inserted.

The abundant variety of colors available in Canson's Mi-Teintes paper means you can make an envelope to complement almost any design.

Lining an envelope with paper that matches or complements a piece of stationery adds another dimension of customization and flair.

MATERIALS ..

Premade envelope
Decorative paper for the lining
Glue stick
A paper cutter and/or craft knife or scissors
Bone folder (for burnishing)

1. Cut the lining paper to ⅛ inch smaller than the envelope's outside width and equal to its height with the flap up.

2. Insert the lining into the envelope and trim around the flap.

3. Remove the lining and trim the bottom edge to the width of the glue strip on the flap of the envelope.

4. Insert the lining into the envelope, making sure to push it all the way in. Apply glue to the inside of the flap portion of the lining, then apply pressure to the glued area to adhere it to the envelope.

5. Fold the flap down and burnish the crease.

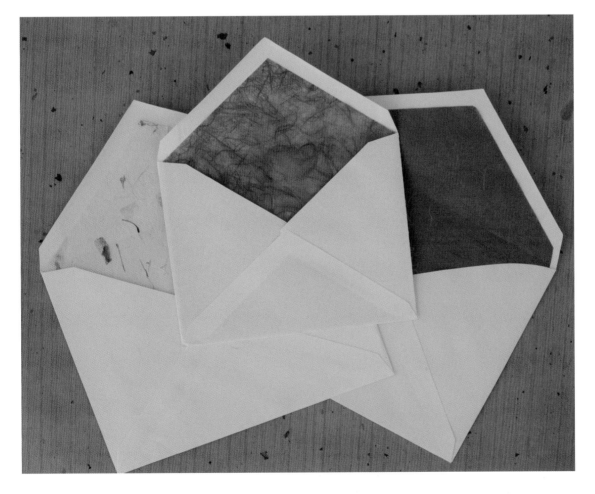

Lined envelopes add a layer of luxury and help reinforce the design theme.

Favors

Typical wedding favors include generic treats such as cookies, candies, seashells, dried flowers, candles, and tiny bubble blowers. Sometimes, they're personalized with the names of the bride and groom, but many of these types of favors never even make it home from the reception—they're left behind and soon forgotten. Wedding guests will treasure the unique custom favors described here that not only celebrate the honored couple but do so with elegance and style. These favors are destined to be appreciated and kept as cherished mementos.

To create a custom CD sleeve, I took apart one I happened to have on hand and created a Photoshop template by replicating the shape and measurements, then added a photo, a personal note, and song titles.

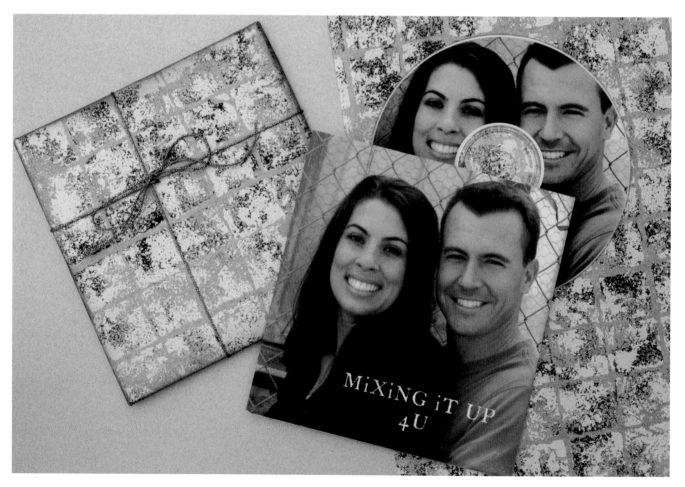

A CD of the couple's favorite songs makes a very personal favor. CD labels are easy to create using Avery templates. *(Font: Letterpress Text)*

Step-by-Step: Candle Favors

Candle favors are perfect for individual place settings but can also be grouped together to form an unusual centerpiece. Personalizing each candle with a beautiful photograph of the couple makes it a true keepsake.

MATERIALS

Matte photo paper
Scissors or paper cutter
Double-sided tape
Candle and glass cylinder
Ribbon, cord, or fiber (optional)

1. Create a page layout equal to the height and circumference of the glass cylinder, plus ¼ inch for overlap. Incorporate a photo of the couple with their names and wedding date.

2. Print, trim if necessary, and wrap the paper around the cylinder. Secure with double-sided tape.

3. Tie a length of ribbon, cord, or fiber around the cylinder if desired.

4. Insert candle.

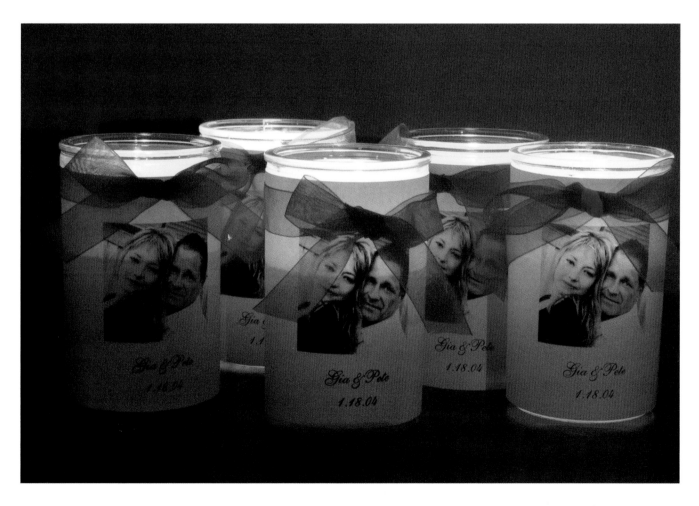

Simplicity itself, and romantic and evocative when illuminated, each candle favor features an engagement photo of the couple and their wedding date. *(Font: Shelley Allegro)*

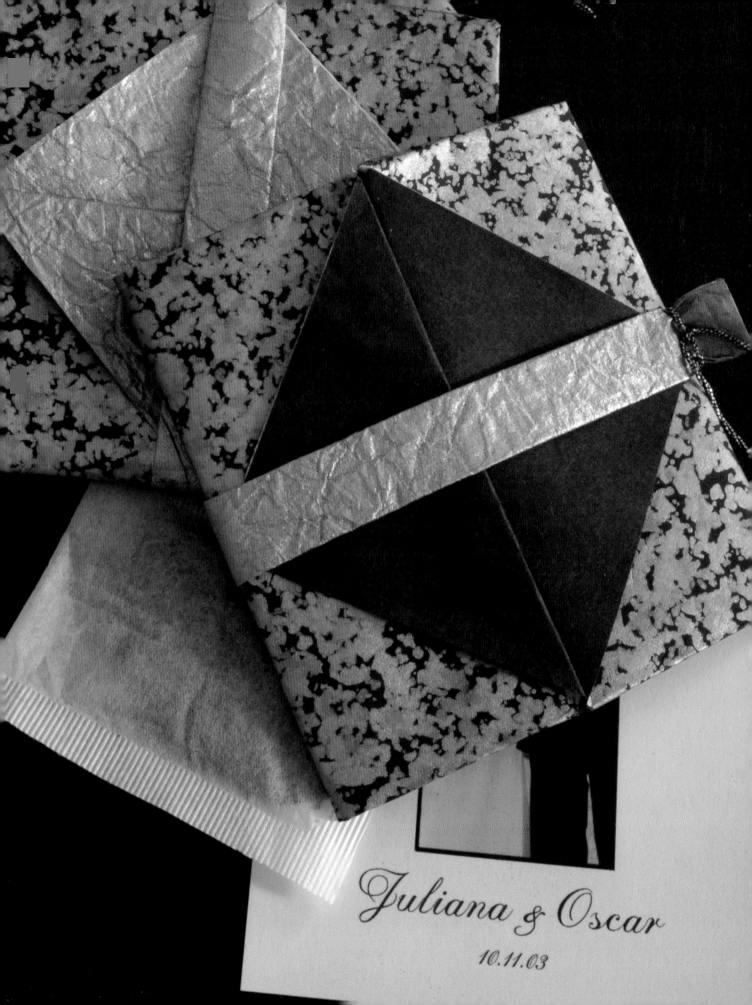

Juliana & Oscar

10.11.03

Japanese-Style Pouch

The band used here to hold the pouch closed is reminiscent of an obi, the traditional sash tied around a kimono. Fill this exquisite pouch with a small treat and a printed card commemorating the occasion. For best results, use Japanese or other flexible papers. Use the bone folder to score accurately and make clean folds.

MATERIALS

One sheet 8- by 8-inch decorative paper
One sheet 8- by 8-inch complementary
 decorative paper
One strip of gold paper $11\frac{1}{4}$ by $1\frac{1}{2}$ inches,
 or an $11\frac{1}{4}$-inch length of $\frac{1}{2}$-inch ribbon
Gold string or fiber
Pouch template
Spray adhesive or double-sided tape
Bone folder
Favor (teabag, bath salts, potpourri, flower seeds,
 or five almonds to symbolize health, happiness,
 wealth, fertility, and long life)
Commemorative card

1. Join the papers together, right sides facing out.

2. Use the template, enlarging it to an 8-inch square if necessary, to mark the fold lines.

3. Score along lines AB, CD, EF, and GH.

4. Fold the upper corner down along scored line AB.

5. Fold point I up to top edge.

6. Fold the lower corner up along scored line CD.

7. Fold point J down to the lower edge.

8. Fold left section in toward the middle along scored line.

9. Fold point K out to left edge.

10. Fold right section in toward the middle along scored line.

11. Fold point L out to right edge.

12. Insert the card and favor.

13. To make the belt, fold the strip of paper into thirds lengthwise, or use the ribbon as is. Wrap it around the pouch so that the ends meet on the right side. Tie gold string around the belt, knot it, and trim.

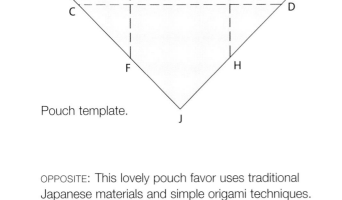

Pouch template.

OPPOSITE: This lovely pouch favor uses traditional Japanese materials and simple origami techniques.

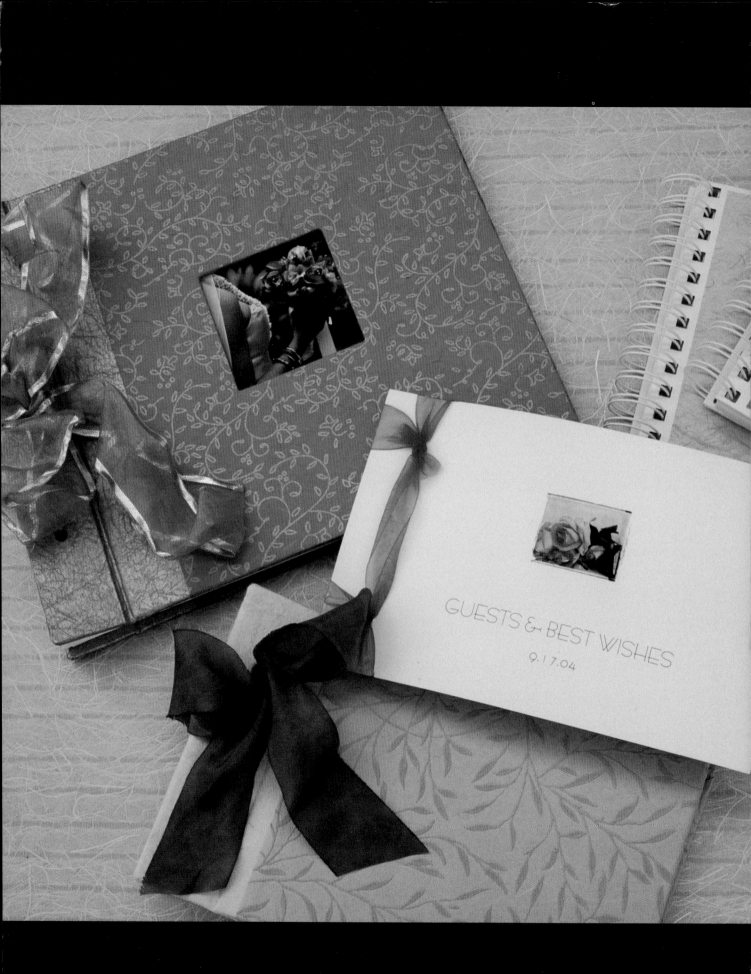

GUESTS & BEST WISHES
9.17.04

Chapter 8

GUEST BOOKS & ALBUMS

Many photographers include albums in their wedding packages. The wedding album will hopefully endure as a family heirloom to be treasured for generations to come. As such, it needs to be very well constructed, and archival concerns are paramount. Creating a beautiful yet sturdy handmade album is, without question, an art unto itself, and it's somewhat beyond the scope of this book, but here are some ideas for simple guest books, small- to medium-sized photo albums/scrapbooks, and gifts sure to become keepsakes.

Converting a generic spiral-bound album into an object of beauty is surprisingly easy, and it's the perfect way to create a guest book with plenty of space for thoughts, best wishes, and candid photos. These instructions include steps for creating a window to showcase an image. Alternatively, you could simply mount a photo onto the front cover.

MATERIALS

A photograph

A spiral-bound album (this one is 12 by 12 inches
 and manufactured by Canson)

Decorative paper for cover (a flexible handmade
 type of paper with some "give" is easier to work
 with than a slick commercially produced paper)

Complementary paper for lining

Spray adhesive or PVA and methylcellulose
 (a 50/50 do-it-yourself mixture of PVA and
 methylcellulose will slow the drying, allowing
 you more working time)

Craft knife

Bone folder

Straightedge or ruler

Cutting mat

Ellison die cutter and die (optional)

Delicate handmade paper, a generous length of wired ribbon, and a photograph framed by a die-cut window transform a plain spiral-bound album into a special keepsake.

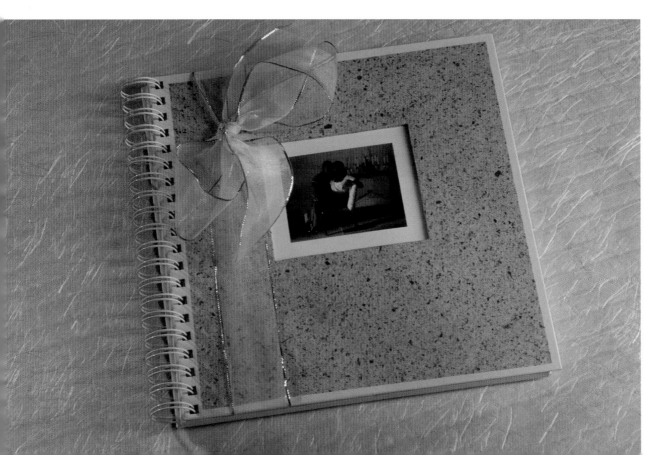

1. Cut two pieces of decorative paper and two pieces of lining paper to size, each about ¼ inch smaller than the album covers in height and width, excluding the ½-inch spine (the border area containing the holes).

2. Remove the cover boards from the spiral binding, being careful not to bend the coil out of shape.

3. Use a craft knife or Ellison die cutter to cut a window in the front cover board.

4. Apply glue to the back of the decorative paper and adhere it to the front cover board, centering it between the top, bottom, and fore edge (the edge opposite the spine area) and leaving the holes for the spiral binding exposed as shown in the photograph.

5. Working quickly so that the glue doesn't dry, flip the cover over and use a craft knife to cut an X from corner to corner in the window area. Turn the flaps in, pulling them snug, and adhere them to the back of the cover. (Make sure no flaps extend into the ⅛-inch border area or they will show after you've adhered the lining.) Burnish the edges of the window opening with the broad end of the bone folder to create a snug bond.

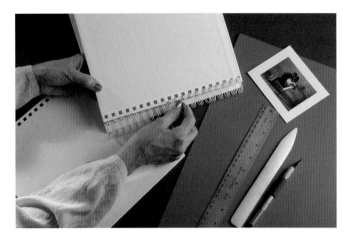

Removing the covers from the binding.

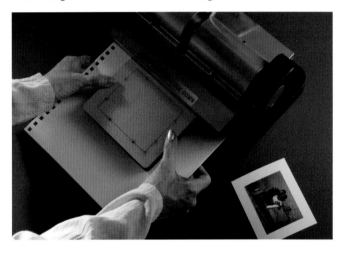

An Ellison die cutter makes it easy to cut a perfect window in a board.

❧ TIP

If the paper you're using contains a geometric pattern, be careful to cut and align it properly: You don't want the pattern to be skewed.

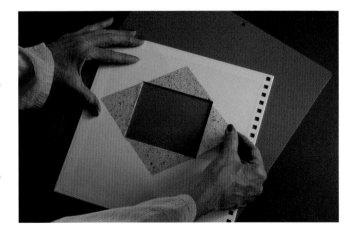

Wrapping the flaps of paper around the edges of the window creates a smooth, neat edge.

6. Print a photo and position it behind the window; secure it with tape.

7. Adhere a lining sheet to the back of the front cover, again centering it between the top, bottom, and fore edge and leaving the holes exposed.

8. Burnish all surfaces with the long edge of the bone folder to remove any air bubbles and to make sure the adhesion is complete.

9. Follow the same steps for the back cover (excluding any references to the window).

10. Reassemble the album.

Create a custom nest-style envelope (see page 120) out of sturdy card stock, add a Velcro "snap," and adhere the envelope to the inside back cover of any album. It's the ideal place for mementos like gift cards, snips of ribbon, and a sample invitation or place card.

Guests

For lined guest pages, remove a few blank pages from the album. Create a lined layout like this one in your computer, then run the pages through the printer and reinsert them into the album.

The intimate size of this little handmade album is just right for showers and even small weddings. Incorporating a simple two-hole edge-sewn binding, endpapers, and the natural deckled edge of fine watercolor papers adds to its considerable charm. Here, the image is printed directly on heavy fine art photo-quality stock.

To use this album as a guest book, instead of using watercolor paper for the inside pages, create a lined page layout on the computer and print several pages on matte printing paper.

MATERIALS

Heavyweight fine art quality printing paper (e.g., Arches Infinity Smooth 355 g/m²) for the covers

140-pound watercolor paper, hot or cold pressed, for the interior pages

Lightweight decorative paper for endpapers (optional)

A piece of cardboard or heavy card stock for the punch template

Craft knife or paper cutter

Bone folder

Cutting mat

Straightedge or ruler

Stitching material—ribbon, waxed linen, or cord (the length should be seven times the height of the book cover, so about 38 inches)

A bookbinding needle with an eye large enough to accommodate the stitching material

Hole punch with a small diameter appropriate to the stitching material (the material will be going through each hole three times but should be very snug)

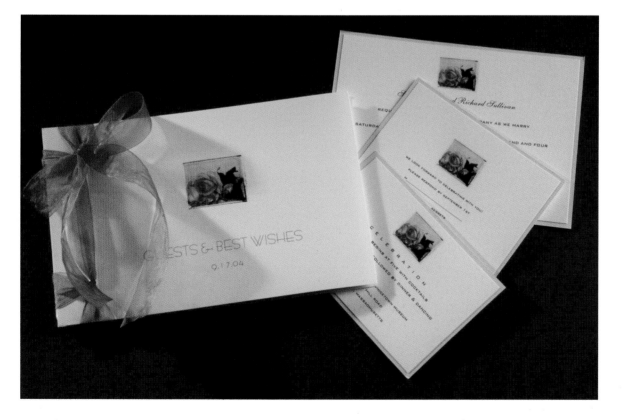

Consider creating an album that coordinates with the wedding stationery. Here, a painterly image transfer (see page 70) provides the perfect theme.

1. Create a horizontal cover layout, 5½ by 8½ inches, and print onto heavyweight printing paper. Cut out. Cut out a back cover with the same dimensions.

2. Score a vertical line on the front cover 1 inch in from the spine edge and fold just slightly to create a hinge effect for flexibility when the book is opened.

3. Out of watercolor paper, cut eight to twelve pages to 5⅜ by 8¼ inches, incorporating the deckle at the fore edge (the side opposite the spine).

4. Score a vertical line 1⅛ inch in from the spine edge of each page and fold slightly.

5. Cut two endpapers to size, 5⅜ by 8¼ inches, if desired.

6. Create a punch template (see page 126) of the same width as the cover with two holes 1 inch in from the spine edge and 1 inch in from the head (top) and tail (bottom) of the book, and use it to punch holes in the covers and all pages. As the pages are slightly smaller than the covers, center them between the head and tail of the template, spine edges aligned, before punching holes in them.

7. Assemble the album, lining up the holes. Use a paper towel or cloth to protect the cover, and a rubber band or clothespins to hold the album together for stitching.

8. Insert the needle and stitching material into the top hole in the front cover, leaving a tail long enough to tie into a bow.

9. Wrap the material over the head of the book and reenter the same hole, pulling the material taut.

10. Wrap the material around the spine and enter the same hole once again, exiting through the back cover.

11. Drawing the material firmly across the back cover, pull it up through the second hole at the tail end.

12. Wrap the material around the spine and up through the same hole. Wrap the material over the tail of the book, then reenter the same hole up through the front cover.

13. Tie the ends firmly, then make a bow or add beads or other embellishments if desired.

Using a punch template ensures that the holes in all the pages will be aligned.

Threading the ribbon through the second hole in the binding, as described in step 11.

Pulling the ribbon through the second hole again to finish (see step 12).

In this traditional album, a hinged spine facilitates page turning and is created by incorporating a gutter, or joint, into the cover design. Decide on the finished size of your album based on the availability of premade pages (available at stationery and art supply stores), or make your own. The finished covers (including gutter) should be $1/4$ inch larger than the pages in width and height. To make a window in the front cover for a photograph, follow the instructions given for the spiral album, or mount a photograph onto a complementary backing and adhere it to the cover.

MATERIALS

Twenty-five to thirty precut, prescored, and predrilled album pages

Sturdy board (e.g., Davey board or bookboard), cut to size, for covers:

For front and back cover—two pieces

For spine boards—two pieces equal in height to cover boards and 1 to $1^{3}/_{8}$ inches wide (spine area on pages should be $1/4$ inch narrower than spine boards)

Linen hinging tape (self-adhesive)

Two sheets decorative paper for covers

One sheet complementary bookcloth or sturdy yet malleable handmade paper for spine

Two sheets complementary decorative paper for cover lining

Fastening material—wide ribbon or screwposts

Two sheets complementary paper for end papers (optional)

Spray adhesive or PVA and methylcellulose (a 50/50 do-it-yourself mixture of PVA and methyl cellulose will slow the drying)

Cutting mat

Craft knife or paper cutter

Clamp or elastic bands

Drill, or hole-punch set and rubber mallet

Ruler

Bone folder

Scrap paper (to protect your work surface)

Gold-stamped wrapping paper complemented by gold *momi* paper and a photo placard create an eclectic album cover. The wired ribbon pulls it all together.

Preparing the Pieces

1. Cut two pieces of bookcloth or handmade paper 2 inches wider and 2 inches taller than the spine boards.

2. Cut two pieces of decorative paper 1¼ inches wider and 2 inches taller than the cover boards.

3. For the cover linings, cut two pieces of decorative paper ¼ inch smaller than the height and width of the finished cover size.

4. Cut two pieces of linen hinging tape 2 inches longer than the spine boards.

5. Lay an album page over each spine board to line up the holes (allowing for a slight overlap of the board at the spine edge); mark and drill or punch holes.

Attaching the Spines to the Covers

1. Lay the spine board on the cutting mat, using the grid to square it. To create the gutter, place the cover board ¼ inch from the right edge of the spine board and aligned at the top and bottom. Peel the hinging tape to expose the adhesive; then carefully join the cover to the spine. Press firmly to adhere.

2. Flip the assembly over and fold over the top and bottom ends of the tape, pushing them into the gutter. Rub the tape down and into the groove using the bone folder.

3. Repeat for the remaining cover.

Adhering the Bookcloth or Paper to the Spine

1. With a pencil, draw a vertical line about 2¼ inches in from the spine edge.

2. Apply adhesive to the bookcloth or handmade paper.

3. Cover the spine area by lightly placing the sticky side of the cloth or paper against the pencil line, centering it over the board at the top and bottom, then pressing in a fanning motion to adhere. (Don't worry about covering the holes.) Use the bone folder to press the cloth or paper into the gutter as well, and to remove any air bubbles.

Basic tools and materials needed to create a hardcover album.

When applying the hinging tape, be careful not to jar the boards out of place.

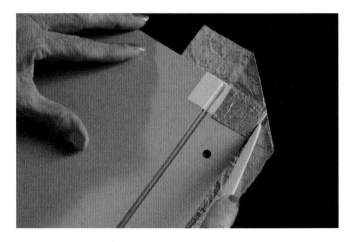

Folding the outside corner of the spine paper and using the bone folder to define the creases.

4. Turn the assembly over and fold in each outside corner at a squared diagonal, then fold the top flap down, the side flaps in, and the bottom flap up, using the bone folder to make sure they're quite snug. Apply more glue as needed.

5. Smooth all adhered surfaces with the broad side of the bone folder to remove any air bubbles.

6. Repeat for the remaining cover.

Adhering the Decorative Paper to the Covers

1. Apply adhesive to the cover paper.

2. Apply the decorative paper to the cover by slightly overlapping the edge of the existing spine paper and centering it over the board at the top and bottom, then pressing in a fanning motion to adhere. Use the bone folder to smooth out the area and remove air bubbles.

3. Turn the assembly over and fold in each outside corner at a squared diagonal, then fold the top flap down, the side flaps in, and the bottom flap up, using the bone folder to make sure they're quite snug. Apply more glue as needed.

4. Apply adhesive to the inside cover papers and adhere to the inside of the cover, centering it carefully. Use the bone folder to nudge the paper into the gutter, being careful not to tear the paper, and smooth out the area to remove air bubbles.

5. Repeat for the remaining cover.

Assembly

1. Use your finger to find the holes in the spine area and make a slight indentation. Use a hole punch and rubber mallet to cut holes.

2. Insert the pages between the covers so that the holes line up and use a clamp or elastic bands to hold the entire assembly together.

3. Insert screwposts or thread a length of ribbon through the holes and tie into a secure knot and then a bow.

The finished spine corner.

Applying the decorative cover paper.

✻ TIP

The techniques detailed within this chapter amount to a crash course in the exploding world of book arts. If you find yourself craving more, magazines and how-to books abound, and classic as well as innovative techniques are being taught in workshops and colleges.

PHOTOGRAPHIC P

HOTOGRAPHIC P

Works
Beyond

barbara

RAPHY

barbara smith

OGRAPHY

barbara smit

OTOGRAPHY

ps & Seminar

Photographi

Photogr

barbara smith

Theodore Samuels together
and Edward Neumann
or of your presence at
n of their children

John Neumann

y of September

t four o'clock

Beverly Hi

n to

ENGAGEMENT SESSIONS

BRIDAL & BABY SHOWERS

Keepsake Photography

WEDDINGS

PREGNANCY

BIRTHS AND BIRTHDAYS

DAY-IN-THE LIFE SESSIONS

SPECIAL EVENTS

SPECIAL EVENTS

4694

94

B.

B. B. Smith

photog

stationery, ha

Chapter 9

THE FINE ART OF
SELF-PROMOTION

As they say, a picture is worth a thousand words. You're a photographer; the best way to let people know about the quality of your work is to show them— what else—a photograph. You've cultivated a style; now use it in your printed materials. Choose outstanding images that are most representative of your unique approach. When it comes to promoting your services, here are some simple and inexpensive ways to get the most bang for your buck.

Putting Yourself on Paper

Not so very long ago, before the digital revolution, unless you were an accomplished "guerilla" marketer, promoting yourself could be prohibitively expensive. It was pretty much impossible for a layperson to design and print professional-looking materials, so expert designers and printers were hired to do the job. All that has changed dramatically. Of course, there will always be a need for the talents of skilled professionals, but you needn't feel frustrated if you can't afford to hire one: The tools are at your fingertips.

Business Cards

Your business cards will probably be your most frequently used form of self-promotion, so make them special: Use good quality card stock, a font that conveys your style, and color. Bear in mind that the materials you use are just as important as the data and even the photograph insofar as communicating who you are and the nature of your business. Be it sleek, high tech, vibrant, or grunge, the look of your printed materials projects a strong initial impression. And it's so easy to print your own cards. (See "Custom Business Cards" on page 148 for instructions.)

Get as creative as you want with your business cards, but make sure they fit in a standard business card holder. Oversized or square cards, however stylish, are destined to be misplaced.

⚜ TIP

It's never too late to implement this very effective marketing strategy: Send out ten business cards to current and former clients on your mailing list—and if you don't have a mailing list, get busy!—along with a note saying, "Thank you for your business! Use these business cards to refer a friend and you will receive a free color 8- by 10-inch print or family portrait discount when they shoot with us and mention your name."

BEYOND DESKTOP PRINTING

If you decide to mass produce your promo piece, find a commercial printer who will guide you or assist you in preparing the digital files for print. Some printers require that files be created in sophisticated page layout programs like QuarkXPress or Adobe inDesign. Be aware that full-color printing can be very costly and makes sense only when you print in sufficient volume to bring the per-piece cost down to a reasonable level.

Mailing Pieces and Brochures

Use the techniques and layouts presented in this book to print your own promotional pieces. Carefully plan the layouts, using graphic design concepts such as balance and contrast, and use type as part of the overall design. Go light on the text for maximum impact and readability. Print onto double-sided matte or glossy card stock for a finished, professional look.

When designing your promotional materials, bear in mind that per piece, desktop printing can be both cost and time intensive compared to that done in commercial shops, so you may want to reserve it for prototypes or for potentially important clients or presentations. On the positive side, you can print on demand, eliminating the prospect of excessive or outdated inventory, and you can even customize each piece to suit the client, or to present your newest work.

Books

Perhaps you've dreamed of having your work published as a fine art coffee-table book. Well, you no longer have to find an agent or a publisher. There are companies that will print your book at a reasonable price. This is probably not something you'll send out in a mass mailing, but it's an impressive item to show potential clients or to send to that big account you're hoping to land.

You can upload your images to a website like Kodak.com, Shutterfly.com, or MyPublisher.com and in about a week you'll have your own hardcover book. If you work on a Macintosh computer, you can design your book using Apple's iPhoto software. It's fairly easy to create a durable and appealing yet amazingly inexpensive custom book for each of your clients. Fill it with their images for a thoughtful, one-of-a-kind gift and include a page thanking them for their business—along with your contact information for others to see.

Keep them coming back! As each anniversary approaches, send your clients a special card featuring a photo from their wedding and include a freebie or gift certificate for a discount on an anniversary photo session.

Easy-to-use websites allow anyone to be a publisher.

Gift Certificates

Let your clients know that gift certificates are available. A portrait session is one of the nicest gifts to receive. Design custom certificates using the techniques set forth in this book, make your own envelope, and tie it with a generous length of ribbon or waxed linen thread.

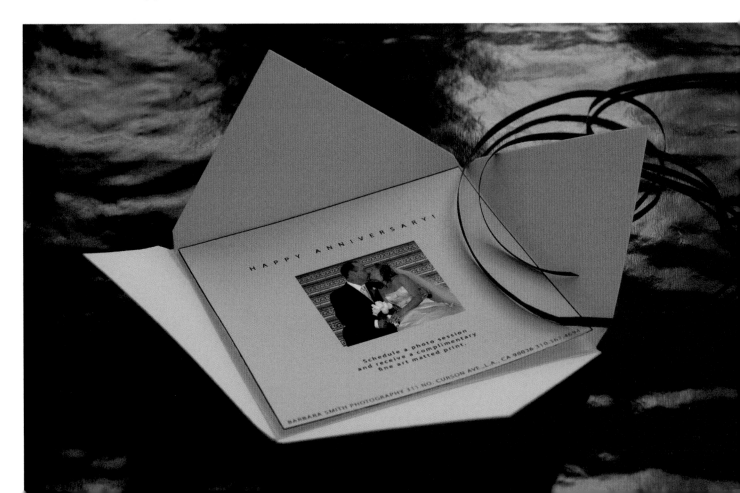

Follow the steps below to set up a business card template in Photoshop. A letter-size sheet of paper yields ten standard business cards, or five folded cards.

1. Choose File>New and set up a page layout that conforms to the size you want your business card to be. A standard business card is 3½ by 2 inches. The image you select will help determine whether a vertical or horizontal layout is most effective.

2. Open an image file. Crop and/or size the image appropriately. Choose Select>All, then Edit>Copy.

3. Return to the business card window and choose Edit>Paste. The image will appear in the middle of the layout; use the Move tool (V) to reposition it. Note that the image is on its own layer; you can edit it, move it, or resize it (Edit>Transform) at any time.

4. Select the Type tool (T). Choose a font and point size. Type the text, placing the various components of related information (e.g., business name, address information, contact information) on separate layers so that you have the ability to edit or move them independently. To do that, after you've finished typing the first component, click on the Move tool, click on the Type tool again, then click on the open window and a new layer will be created. Follow that process for each additional component.

5. Save the file as a template (e.g., Business Card Layers). Flatten the layers (Layer>Flatten Image), then go to Select>All, then Edit>Copy. Save the flattened version as well (e.g., Business Card Flat). (Note: If yours is a vertical card like mine, before copying go to Image>Rotate Canvas>90° CW.)

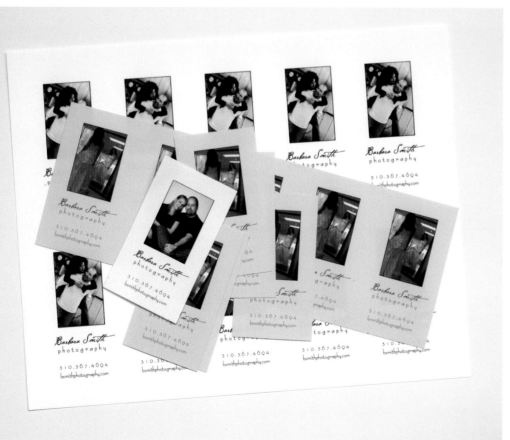

The contact information on your business card should be easy to read. Choose an image with a simple, striking composition. Once you've created a template, swapping photos is effortless.

6. Open a new file using the Letter size default layout. Using the Rulers (make sure Rulers is checked in the View menu), drag out guides as shown on the right.

7. Go to Edit>Paste. A copy of your flattened business card will appear in the center of the layout. Use the Move Tool (V) to drag it into position against the upper left-hand guides. If you have the Snap feature checked in the View menu, the card will jump into place when it nears the guides. Continue pasting nine more card layouts and positioning them against the guides.

8. Print and cut the cards to size.

9. Save the layered file (e.g., Business Card Sheet). In the future, use it as a template: Simply duplicate the file, discard the existing card layers, and replace them with a new set.

Set up guides as shown to create ten horizontal cards.

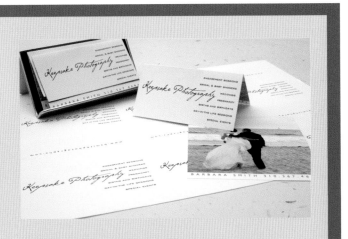

✣ TIP

Print out some custom business cards detailing your business to give to each client featuring *their* image. They'll be sure to hand them out and talk you up—word-of-mouth advertising that's priceless!

Use this setup for vertical cards, and paste the layout into each of the ten spaces.

DOUBLE-SIDED BUSINESS CARDS

For double-sided business cards, follow the same steps as for a single-sided card. When it comes time to print, turn off the layers for the second side while printing the first, then turn off the layers for the first side while printing the second. Always test print on inexpensive paper: You may need to tweak the positioning a bit to make both sides of the cards line up perfectly.

Double-sided folded cards allow you to convey a surprising amount of information, such as a list of your services or a sizeable photo.

Self-Promotion in the Digital Age

There seems to be a pretty equal division between those who like to view "hard" copies of printed materials and those who prefer digital. As time marches on, digital media will become more and more accessible and more popular.

Compact Discs and DVDs

If you don't yet have a website, the simplest way to show someone your work is to send them a CD or DVD. Your clients will also appreciate receiving their proofs in an accessible digital format. Make a custom label for each client. You can purchase Avery CD labels at office supply stores. Choose a suitable shot to print on the label along with your contact information—remembering that there will be a hole in the middle—and adhere it to the disk. Take it a step further and design a jewel case insert: You can include a wealth of information about your products and services. Download templates from Avery.com. Programs like Window's Photo Story or Apple's iPhoto, iMovie, and iDVD will help you create a CD or DVD movie or slideshow of your work, and you can even add music.

Websites

Finally, if you're in business, you should have a website. You can upload your own blog, slide show, newsletter, video, and more. To build your own website, check out sites like BigFolio.com. My website was designed by a very talented and creative man, Edouard Sitbon, who lives overseas. We never spoke—everything was done via e-mail—until the moment he called to congratulate me and announce that my site had been uploaded to the Web. To this day, I marvel at what a smooth, seamless process that was, and continues to be as we add new elements.

Having my own website has made it much easier for me to communicate with existing clients and to find new ones!

Appendix A: Photography Equipment

When it comes to equipment, photographers often get caught up in bigger, better, and more. For the purposes of creating keepsake photography, less is more. We can perform our work more efficiently, concentrating on the heart—and art—of the matter, if we're not saddled by more equipment than we really need.

Choosing a Camera

An expensive camera doesn't guarantee great photographs, just as an inexpensive camera doesn't negate award-winning images. Cameras don't shoot people; people shoot people. The camera is a tool to help you manifest *your* creative vision.

If you're in the market for a camera, here are some general guidelines.

FILM OR DIGITAL?

The very first consideration when purchasing a camera today is "film or digital?" If you're just getting started, digital may be the answer. The quality *is* there, and most people cannot tell the difference. And contrary to popular belief, you *can* capture artistic shots that are every bit as effective as if they were taken with film. What's more, using a digital camera will enable you to learn the basics of exposure and composition much faster than if you were using a conventional camera, and at a significantly lower cost: You can see the pictures immediately, and there's no film or processing expense.

On the other hand, each brand and type of film has its own distinctive characteristics that render it suitable for a specific look or purpose.

COMPACT OR SLR?

The term *single lens reflex* (SLR) refers to the viewing mechanism that allows you to see *exactly* what you're going to get before you press the shutter release button. SLR cameras are bigger and heavier than compacts, but if you're serious about photography, you'll probably want one. There is a steeper learning curve involved, but you'll benefit from the ability to control all the settings and by the availability of interchangeable lenses. If you already own a conventional SLR and are looking to buy a digital camera, it makes sense to choose one that is made by the same manufacturer, as the lenses and many accessories may be interchangeable.

With a *compact camera*, you can simply point and shoot and expect good results. Compact cameras are small, lightweight, portable, and fully automated with programmed exposure settings, auto-focus or fixed-focus lens, and a built-in flash unit; many are now also equipped with a zoom lens. Point-and-shoot cameras do *not* have interchangeable lenses, and what you see through the viewfinder is *not* precisely what you will see in print as with an SLR.

Lenses

The wider the angle of the lens, the shorter the focal length (the distance in millimeters from the optical center of the lens to the film plane or sensor), and the larger the view the lens will take in. Longer focal lengths narrow the field of vision but will bring a distant subject closer.

A standard focal length of 50mm is similar to the field of vision of the human eye and gives photos a natural, neutral perspective. Henri Cartier-Bresson used a 50mm lens almost exclusively, and to this day it remains the lens favored by many photojournalists.

Zoom lenses offer a range of focal lengths in one lens but may not be quite as sharp as fixed-focus (non-zoom) lenses. In spite of that, they're perfect for events like weddings because you can move around without having to change lenses and vary the perspective on a moment's impulse. Common focal-length ranges of zoom lenses are 28–80mm, 35–70mm, 70–120mm, and 80–210mm. Wider ranges are available, but the lenses are heavier and/or bulkier.

A *wide-angle lens* (focal length below 35mm) takes in more of a scene but can make everything look far away. People close to the edge of the frame, or too close to the lens, can appear distorted. Wide-angle lenses are best used for capturing scenic, architectural, and creative perspectives.

Telephoto lenses (above 70mm) cause far-off subjects to appear closer, and you can capture close-ups without being on top of your subject. The potential problem here is blur from camera shake. With a long lens, everything gets magnified—not only the image, but movement as well.

Portrait lenses (85–135mm) facilitate flattering head-and-shoulder shots by compressing the perspective slightly to make the face, particularly the nose, look flatter.

Film and Memory Cards

When choosing film, the very first consideration is whether to shoot color or black and white. When shooting digitally, everything is in color, but you can easily transform color "captures" into black-and-white photos after the fact (see page 54).

Most photographers keep a favorite selection of tried-and-true films on hand. Try to familiarize yourself with a couple of brands and speeds before adding others.

COLOR FILM

When shooting images that may be united in an album, it's a good idea to maintain a consistent color palette. This is easily accomplished by selecting a "family" of films. Fuji and Kodak offer a full range of professional films that meet varied shooting requirements and perform well under differing lighting conditions.

BLACK-AND-WHITE FILM

I will mourn the day black-and-white film disappears. Part of it is nostalgia, I'm sure, but there's just *something* about the quality of black-and-white film.

- Kodak T-Max 400 is a great mid-purpose film (when conditions are not too bright and not too dark) with a tight grain structure that translates into sharp blacks and whites.

- Kodak Black & White Plus 400 is a C41 film—intended for processing in color chemistry—which means you can take it to any lab.
- Kodak T-Max P3200 (which I generally rate at 1600 for improved tonality and shadow detail) is perfect for very low light situations and eliminates the need for a strobe (an electronic flash device that provides artificial lighting). It produces grainy, romantic, fine art images.
- For infrared photography (see page 76), choose Kodak HIE High Speed Infrared film and set your ISO to 200.

MEMORY CARDS

Removable memory cards are the digital equivalent of film. The higher the volume of the card—in other words, the more megabytes (Mb) or gigabytes (Gb) per card—the more photos you can store. However, the capacity depends on the resolution (see page 156) you select within your camera's program—the bigger the file size, the fewer images the card will hold. More and more photographers are opting to shoot in "raw" (i.e., uncompressed) mode, which requires lots and lots of bytes!

ISO

ISO refers to film speed. The faster the film, the more sensitive it is to light, and the less light you need to get a good shot. Faster film has a coarser, more visible grain structure, which results in less sharpness and color saturation. The decision of which film speed to use should be based on available light *and* the potential for movement. Are you shooting at dawn, in broad daylight, or in the evening? Indoors or outdoors? Is your subject likely to be moving or stationary? Film termed "slow" (with an ISO rating of 100 or 200) requires the most light and exposure time, while medium (ISO 400) to fast film (with ISOs of 800, 1600, or even 3200) calls for much less light and time. When in doubt, use a faster film.

Digital cameras require that you choose an ISO comparable to that of the film appropriate to a particular shooting situation. In daylight, an ISO of 200 would be appropriate. In low light, you would probably select an ISO of 400 or 800. Faster speeds tend to increase "noise," which is similar to grain. One of the most exciting advantages of shooting digitally is that you can change the ISO from shot to shot, whereas with film you would need to change the roll.

Appendix B: Focusing & Exposure

The newer point-and-shoot cameras are almost fool-proof. Good composition, good lighting, and you're good to go. If you're using an SLR, there are two things you will want to control: focus and exposure.

Controlling Focus

Some photographers always use manual focus control. When photographing weddings and other events, I prefer to use my camera's auto-focus capability—it's one less thing to think about, and it allows me to shoot photos in rapid succession.

Focus lock allows you to change the composition of your photo *after* focusing. This is imperative when you want to photograph a subject off center, or when two people are standing together and the camera "wants" to focus on the space between them. To use focus lock, train your lens on the subject (or one of the subjects if they're next to each other), press the shutter release button halfway down to initiate focus, then recompose the photograph and shoot.

Controlling Exposure

Exposure is all about how much light reaches your film or digital processor. This is determined by the size of the lens opening (the *f*-stop or aperture) *and* by the length of time the shutter remains open (the shutter speed). The correct ratio results in a photograph that is neither too dark nor too light, but just what you had in mind.

Most modern cameras allow manual exposure control as well as programmed modes that practically guarantee you'll get your shot. When shooting events (as opposed to portraits), I opt for a combination of manual and program by choosing a "priority" mode—either aperture priority or shutter speed priority—which allows the camera to determine the proper exposure.

APERTURE PRIORITY

With aperture priority, you select the aperture, and the camera determines the proper shutter speed for an ideal exposure. Typically, the reason for choosing one aperture over another is to control the *depth of field*, or the portion of the shot that will appear in focus. The wider the aperture, the shallower the depth of field, and vice versa. Another reason is to accommodate a specific film. If you're using a slow film and you're in a low-light situation, you'll want to choose a wide aperture to let in more light.

A wide aperture (e.g., *f*4) allows you to throw the background out of focus to minimize distractions and to shoot without a flash or strobe, even in low-light situations, for a soft, natural look.

A narrower aperture (e.g., *f*11 or *f*16) enables you to capture large groups of people with everyone in focus and to shoot scenic layouts with a deep field of focus.

SHUTTER SPEED PRIORITY

With shutter speed priority, you set the shutter speed, and the camera determines the correct aperture. There are many instances in which you might want to set a specific shutter speed. Perhaps you want to freeze the action to preserve the bride and groom's first kiss as husband and wife, in which case you would choose a fast shutter speed, say 1/500 of a second. Or, in order to capture some motion blur during the first dance of the newlyweds, you might opt for a slow shutter speed, say 1/15 or 1/30 of a second.

F-STOPS & SHUTTER SPEEDS

The most confusing aspect of photography may be the numbering system. For example, an aperture, or *f*-stop, of *f*8 is larger than an aperture of *f*16. That's because those numbers are actually fractions. An *f*-stop of *f*8 means 1/8 and so it's larger than *f*16, or 1/16. The smaller the aperture, the larger the number. In terms of shutter speed, however, the numbering makes more sense: The slower the shutter speed, the lower the number. A shutter speed of 30 (or 1/30 of a second), for example, is slower than 500 (or 1/500 of a second).

Appendix C: Working with Digital Images

More than half the images in this book were taken with a film-based camera; however, the *stationery* was created using images that have subsequently been digitally scanned, digitally corrected, and digitally printed using an ink-jet printer. If you use a conventional, rather than digital camera, *and* you own a computer, when you take your film in for processing, ask that it be scanned as well. The cost is nominal, and the value of being able to manipulate your images is incalculable: You can correct poor exposure, improve colors, remove distractions, crop, and apply creative effects.

To manipulate a digital image, you must have some type of digital imaging software. Such programs run the gamut from basic to highly sophisticated. Which program you choose is a matter of how much you want to spend, how much you want to learn, and how much you intend to use it. Adobe Photoshop is the standard among imaging professionals. It is a bit pricey, but there is a less expensive version, Photoshop Elements, that has many of the same features. Many digital cameras are now packaged with imaging software.

How to Create and Work with a Digital Image

There are three methods for getting an image into your computer:

- Transfer it from a digital camera.
- Scan an existing photograph.
- When you take film in to the lab for processing, also have it scanned and put on a CD that you can then access.

Once you have saved a digital file, you can incorporate it into any of the projects detailed within this book.

Resolution

One of the most important—and often confusing—aspects of digital imaging is *resolution*. Digital images are made up of tiny squares called *pixels*. The higher the resolution, the smaller the pixels and the more "information," or detail, in the picture—and the more memory, space, and speed you'll want in your digital equipment. You can control the number of *pixels per inch* (ppi) through your software (e.g., Photoshop) to

determine the size and quality of the image. *Dots per inch* (dpi), on the other hand, refers to scanner and/or printer resolution; it's not something that can be changed in Photoshop. Most of us see a printed digital image with a resolution of 200 dots per inch or more as continuous tone—it looks just like a photograph. Cameras, scanners, monitors, and printers each have their own resolution settings.

For our purposes, that of working with images that will appear on stationery no larger than, say, 5 by 7 inches, capturing or scanning photographs at high resolutions (e.g., 200–300 dpi) and using the preset "fine" or "photo" printer settings will most likely give us sufficient sharpness—*if* the image is sharp to begin with.

Color Management

Color management is another challenge of digital imaging. The difference between the colors you see in your camera's viewfinder, how the camera (or scanner) interprets them, how they appear on the monitor, and how they look when printed can be dramatic. Specially coated papers have specific profiles that insure color predictability and consistency *provided you select them in your printer dialog box*. You may need to calibrate your monitor, or you can adjust the color settings in your imaging program to bring the final print in line with your visual intention.

The Digital Workflow

Just as papers can pile up on your desk, digital files in various stages of progress can pile up in your computer, many of them lost for all intents and purposes, yet taking up precious disk space. It's a good idea to get in the habit of following an organized digital workflow. The workflow offered here is appropriate to Adobe Photoshop, the image-editing software program favored by most pros, but the concept is easily adapted to other programs.

1. Create a new folder for each client (e.g., Smith) and, within that folder, create a new folder for each project (e.g., Smith Invitation).

2. Open an image file. Before doing anything else, either duplicate the image or go to File>Save As and save with a

new name (e.g., Smith Invitation Image) within the client project folder. Close the original pristine image.

3. Retouch the photograph, if necessary, then incorporate it into a layout as detailed in Chapter 6.

4. Save the file.

Working with Layers

The seemingly humble Layers feature is one of the most powerful and important aspects of Photoshop, allowing you to make any number of corrections *at any time* without affecting the underlying layers. Flattened files, on the other hand, are convenient for sending to clients, printing, and for copying and pasting into other files, as described in Chapter 6.

When working with the full version of Photoshop, you'll probably use the Layers feature, cleaning up on one layer, improving contrast or tone on another, adding text on another. It's a good idea to save the layered file (e.g., Smith Invitation Layers) in case you need to make any changes to a specific layer. Then flatten the layers and save the file under a new name (e.g., Smith Invitation Final). Flattened files are easier to cut and paste and are also very useful when "ganging" more than one layout onto a page for printing (e.g., two invitations, or four response cards).

Sample Photoshop Retouching Workflow

In Photoshop, there's *always* more than one way to accomplish a procedure. Since this is not a book on Photoshop per se, I'm offering general guidelines that require the least amount of explanation. There are shortcuts and alternate ways of performing many of the steps provided here. If you know a better way to do something, by all means, do it!

1. Duplicate the Background layer. In Layer Properties, name the layer (e.g., Cleanup). Naming your layers allows you to identify them easily for future reference. With this layer highlighted in the Layers Palette, use the Clone Stamp Tool (S) in tandem with the Healing Brush Tool (J) to retouch the image as necessary, repairing or removing distracting elements such as scratches, telephone wires, litter, blemishes, etc.

2. Add a Levels or Curves Adjustment Layer and correct the tonality, contrast, and/or exposure. Increasing the con-

trast can add "oomph" to a lackluster photo. In Layer Properties, name the layer (e.g., Tone & Contrast).

3. If necessary, for color images, add a Color Balance Adjustment Layer and add or subtract color where needed.

4. Now you might want to duplicate the Cleanup layer, rename it, and use the Burn Tool (O) to deepen, or "sculpt," the shadows. Use the Dodge Tool (O) to enhance the highlights. Be sure to adjust each tool's exposure setting in the Options bar to enable subtle effects.

5. Crop and resize as necessary.

6. Save the layered file. Save a flattened version for copying.

Individual layers may be deactiviated or returned to at any time, *until and unless the file is flattened*, for further work.

COPY SHOPS

Even if you're not a "computer person," it's easy to achieve beautiful results using a photocopier. Before I set up my digital workstation, Kinko's was my home away from home.

Whenever possible, use the self-service machines—it's less expensive than having the shop do the work for you, and the staff will help you if you have any questions. In addition to making basic black-and-white copies, other products and services may include:

- Color copies—considerably more expensive than black-and-white copies, so you need to plan carefully
- Black-and-white copies on colored paper—a great yet inexpensive way to add a dimension of color to your layout
- Glossy stock—gives copies a "photo finish"
- Making copies larger or smaller, darker or lighter, or using different sizes of paper
- Dual-sided printing—adds a professional touch to stationery and promotional pieces
- Computer services such as scanning and text layout

Resources

Recommended Reading

Cantrell, Bambi, and Skip Cohen. *The Art of Wedding Photography.* New York: Amphoto Books, 2000.

Cantrell, Bambi, and Skip Cohen. *The Art of Digital Wedding Photography.* New York: Amphoto Books, 2006.

Carr, Kathleen. *Polaroid Manipulations.* New York: Amphoto Books, 2002.

Carr, Kathleen. *Polaroid Transfers.* New York: Amphoto Books, 1997.

Eismann, Katrin. *Photoshop Restoration and Retouching.* Indianapolis: Que Books, 2001.

LaPlantz, Shereen. *Cover to Cover: Creative Techniques for Making Beautiful Books, Journals, and Albums.* New York: Sterling, 1998.

Maurer-Mathison, Diane. *Art of the Scrapbook.* New York: Watson-Guptill, 2000.

Milsom, Hugh. *Infra-Red Photography.* Faringdon, UK: Fountain Press, 2001.

Murray, Elizabeth. *Painterly Photography.* Bristol, UK: Pomegranate Books, 1993.

White, Laurie. *Infrared Photography Handbook.* Buffalo, NY: Amherst Media, 1995.

Williams, Robin. *The Non-Designer's Type Book.* Berkeley, CA: Peachpit Press, 2005.

Supplies and Equipment

ARCHIVAL SUPPLIES
Light Impressions
P.O. Box 787
Brea, CA 92822-0787
800-828-6216
www.lightimpressionsdirect.com

Lineco, Inc.
P.O. Box 2604
Holyoke, MA 01041
www.lineco.com

CRAFT TOOLS
Fiskars Brands, Inc.
2537 Daniels Street
Madison, WI 53718
866-348-5661
www.fiskars.com

DIE CUTTERS
Ellison Educational Equipment, Inc.
25862 Commercentre Drive
Lake Forest, CA 92630-8804
800-253-2238
www.ellison.com

INKJET PRINTERS
Epson
P.O. Box 93012
Long Beach, CA 90806-2469
800-463-7766
www.epson.com

PAPERS
Canson USA
www.canson-us.com
Mi-Teintes papers, Arches Infinity digital papers, and spiral books

Graphic Products Corporation
455 Maple Avenue
Carpentersville, IL 60110-3004
800-323-1660
www.gpcpapers.com
Decorative papers

Hawk Mountain Paper
314 Ziegler Road
Leesport, PA 19533-9402
888-807-2248
www.hawkmtnartpapers.com
Digital printing papers

Hiromi Paper International
2525 Michigan Avenue, Unit G-9
Santa Monica, CA 90404
866-479-2744
www.hiromipaper.com
Decorative papers

Strathmore
39 South Broad Street
Westfield, MA 01085
800-353-0375
www.strathmoreartist.com
Ink-jet vellum, digital, and watercolor papers; spiral books

PHOTOGRAPHIC EQUIPMENT
Daylab
41136 Sandalwood Circle
Murrieta, CA 92562
800-235-3233
www.daylab.com
Slide copiers

Polaroid Corporation
800-343-5000
www.polaroid.com
Cameras and film

Tamrac, Inc.
9240 Jordan Avenue
Chatsworth, CA 91311
800-662-0717
www.tamrac.com
Camera bags, backpacks, and cases

Tamron USA, Inc.
10 Austin Blvd.
Commack, NY 11725
631-858-8400
www.tamron.com
Camera lenses

RIBBON

May Arts
1154 East Putnam Avenue
Riverside, CT 06878
203-637-8366
www.mayarts.com

Midori, Inc.
708 Sixth Avenue North
Seattle, WA 98109
800-659-3049
www.midoriribbon.com

Fonts

FONT RESOURCES
Myfonts.com
Emigré.com
Fontcraft.com
Identifont.com

FOUNDRIES FOR FONTS USED IN THIS BOOK
Adana—astype
Alea—astype
Arial—Monotype
Bank Gothic Light—Bitstream
Bauhaus—Linotype
Bernhard Fashion—Linotype
Bernhard Modern—Linotype
Bickley Script—Letraset
Canterbury—Red Rooster
Caslon Open Face—Linotype
Century Gothic—Monotype
Copperplate Gothic—Linotype
Diana—ParaType
Duet—Wilton Foundry
Ellida—Wiescher Design
Garamond—Linotype
GillSans Light—Linotype
Letterpress Text—Chris Costello
Liana—ParaType
Lithos Pro—Adobe

Minion—Linotype
Mrs. Eaves—Emigré
Mistral—Linotype
Myriad Pro—Linotype
Nat Vignette Ornaments—
 ParaType
P22 Art Nouveau—IHOF
P22 Cezanne—IHOF
P22 DaVinci—IHOF
P22 Dearest—IHOF
Prints Charming—TypeArt
Papyrus—Linotype
Royal Classic—Wiescher Design
Ruthie—IHOF
Scriptina—Apostrophe
Shelley Allegro, Andante, and
 Volante Script—Linotype
Sterling—Canada Type
Zapfino—Linotype

Index